AIRBORNE

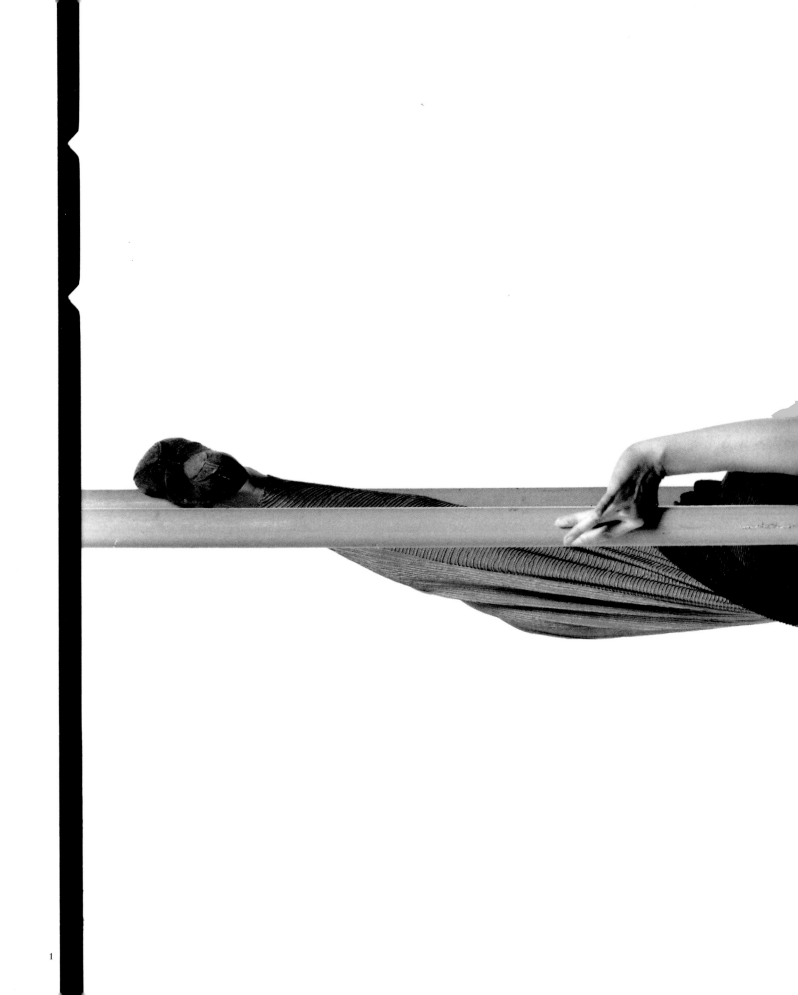

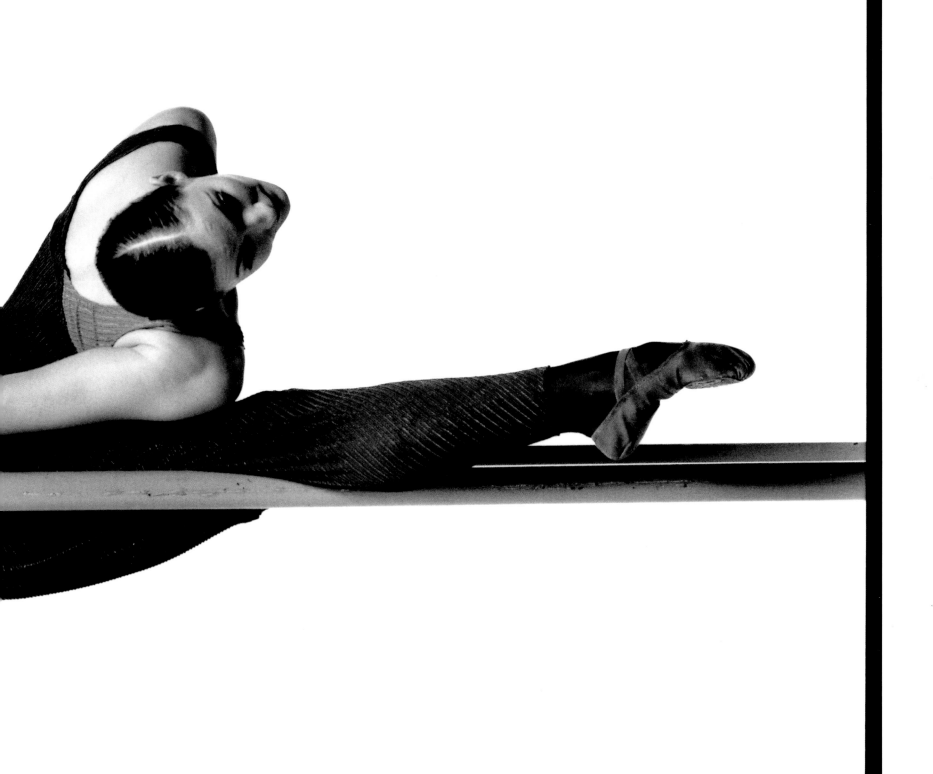

AIRB

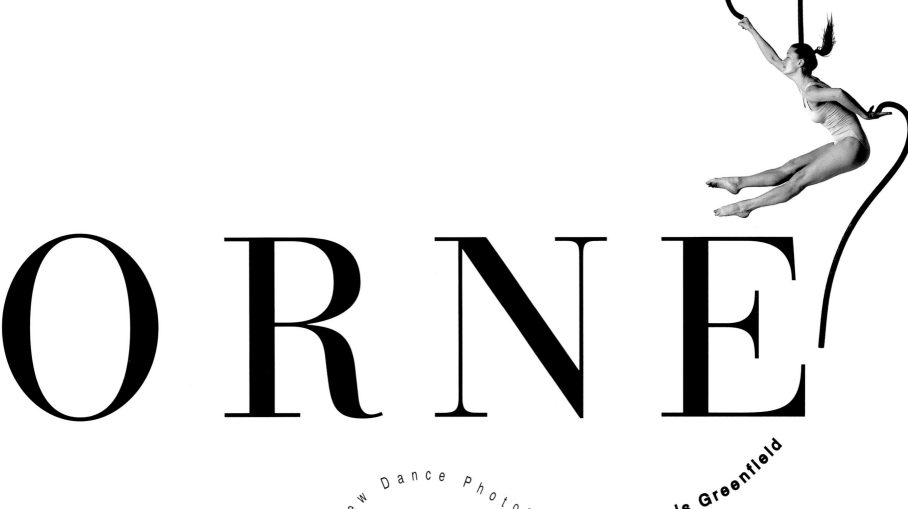

ORNE

The New Dance Photography of **Lois Greenfield**

With a Preface by
William A. Ewing
and a
Critical Commentary
by William A. Ewing
and Daniel Girardin

CHRONICLE BOOKS
SAN FRANCISCO

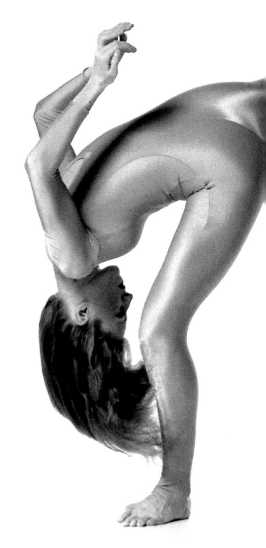

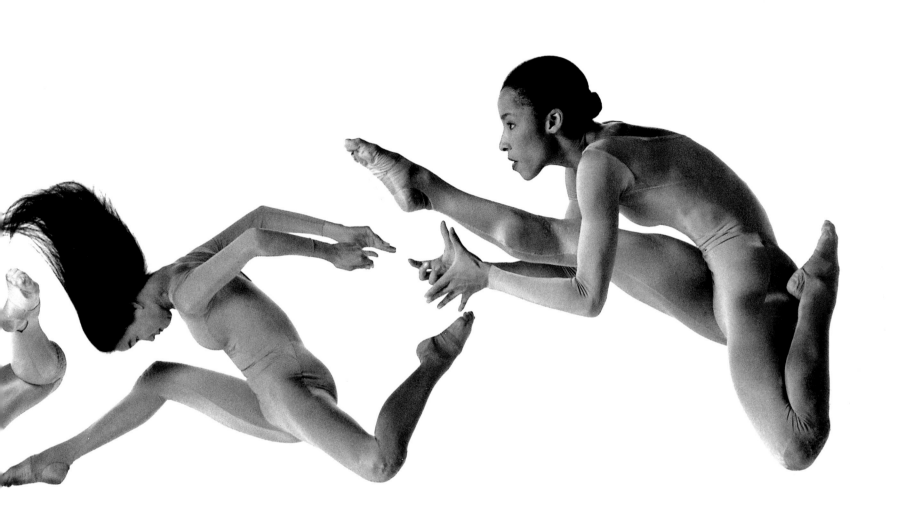

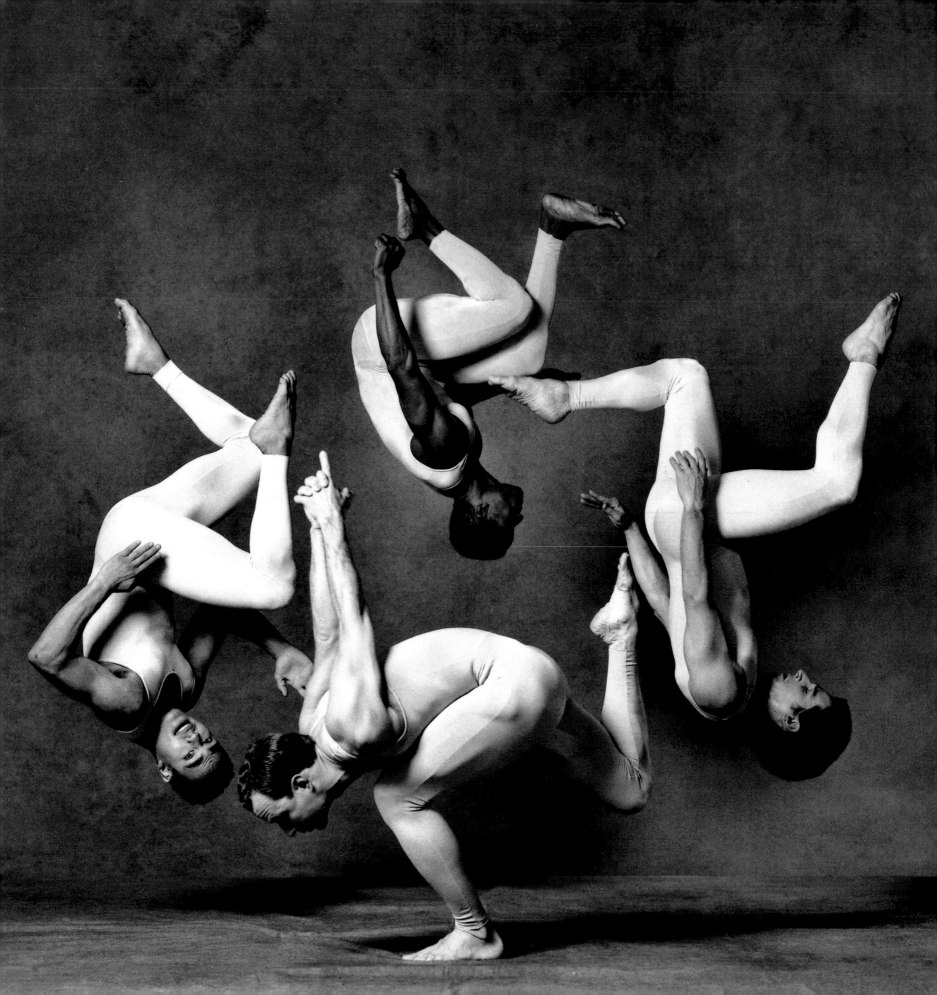

Title page
Ashley Roland 1995

Design: William A. Ewing

First published in the United States
in 1998 by Chronicle Books

Copyright © 1998 Thames and
Hudson Ltd., London
Photographs copyright © 1998
Lois Greenfield

Printed in Hong Kong

ISBN 0-8118-2155-2 pb
ISBN 0-8118-2171-4 hc

Library of Congress Cataloging-in-
Publication Data available.

Cover design: Carole Goodman

Distributed in Canada by
Raincoast Books
8680 Cambie Street
Vancouver, B.C. V6P 6M9

10 9 8 7 6 5 4 3 2 1

Chronicle Books
85 Second Street
San Francisco, CA 94105

Web Site: www. chronbooks. com

CONTENTS

PREFACE

The photography of dance goes back more than one hundred years, yet for all its bright, transcendent moments, there is some question as to whether it truly constitutes a tradition. A tradition implies a process of evolution, of continuity – in short, of building upon the past. So, for instance, *fashion photography* can be said to have a tradition in that its best practitioners are aware of the work of their predecessors, have absorbed their teachings, and have then gone on to create fresh visions.

But whereas neophyte fashion photographers learn to swim in a veritable sea of published imagery, no such advantage is accorded dance photographers, who for the most part have to make their way unaided. Few are the books and magazines devoted to the best of this difficult and demanding art, and few the mentors to guide them. Thus, the aspiring dance photographer has constantly to reinvent the wheel.

Many dance photographers have started out elsewhere: some as commercial studio photographers who happened to be equipped with the necessary props and lighting; others as specialists in glamour portraiture, adept – to varying degrees – at *still* poses that were merely suggestive of movement. Many fewer have been contracted by a specific company to document as matter-of-factly as possible its staged performances and backstage activities. And still others are local press photographers assigned to cover the dress rehearsal of a visiting company (when fires and murder scenes are in short supply). With such varied agendas, and the lack of professional training at a high level, it is no surprise that so much dance photography in books, magazines, newspapers and promotional brochures is stilted, servile and false.

Some years ago, while I was writing an historical survey of dance photography, I became familiar with Lois Greenfield's work and saw that her imagery was clearly of another order. Its dynamism, its precision and its breathtaking illusionism – whereby human beings were seen to fly or float effortlessly through infinite space – showed her to be the finest of contemporary practitioners. I particularly appreciated the fact that Greenfield was able to serve the interests of the dancers and their choreographers while retaining her allegiance to *her* chosen medium of expression. In 1992 we agreed to collaborate on a book and exhibition, and, wanting to know more about her approach, I sat in on one of her photographic sessions.

Lois had decided that a session with a small group of performers from the Parsons Dance Company would be more revealing of her approach than work with a single dancer. Moreover, she felt a particular affinity for their choreography.

I showed up a little early one afternoon, curious to see what kinds of preparations were called for, and placed a chair as close to the set (a twelve-foot-square area with a background of white paper) as I could, taking pains to have an unobstructed view of the photographer behind her tripod-bound Hasselblad. I knew that Lois was seeing everything reversed in her viewfinder, so that a dancer leaping in from the right would appear to be coming in from the left and vice versa.

I found the session astonishing, though not for the reasons I had anticipated. Lois Greenfield's imagery is distinguished by a certain nonchalance: the dancers appear to have lifted themselves into the air, waited for the photographer to snap the shutter, then deigned to return to earth. Naively, I had assumed that I would be seeing such images in the flesh, as it were, the only difference being that these 'images' would be in color. I had forgotten the fundamental truth that all photographs 'lie'. It had not occurred to me that each 'shot', with its complex ensemble of movements and gestures, would be over and done with in a split second, and that the eye would never be able fully to take it all in.

As the dancers performed for each take, I could see nothing in front of me that remotely resembled a Greenfield image; all I saw were heavy, sweating bodies thudding about, the strenuous movements accompanied by sharp exhalations of breath as they landed. I watched the dancers repeat each take with minor variations according to Greenfield's directions but the action never seemed to coalesce into the elegant, ordered motif I was expecting.

Yet the photographer seemed to take it all in her stride; I noticed that she looked through the viewfinder only occasionally, as if to verify her decisions rather than select the instant to take the picture. It dawned on me that the action was unfolding too quickly to be (1) observed and then (2) acted upon; Greenfield was forced to envision what was *about* to happen, timing her shutter release accordingly. Thus, seeing the picture in the viewfinder would mean only that she had missed it. This implied not only a total mastery of her apparatus, but also an acute awareness of the nuances of movement.

Suddenly she announced that the session was over; she had what she wanted. The obvious exhaustion of the dancers made me realize that their efforts had to be budgeted. But though Greenfield seemed well satisfied, I was secretly convinced that the session had been a flop.

A few days later I returned to the studio to see the results. I was amazed: there on the contact sheets were the trademark Greenfield images that had eluded me on the set. In image after image, the forms of the dancers were the epitome of grace and lightness, and the three-dimensional 'chaos' I had witnessed first-hand was transcribed on paper as coherent, ordered imagery. Greenfield's approach was therefore nothing like the act of straightforward 'reportage' I had naively assumed it to be, but was rather a complex refashioning of her 'raw material' – dance – into works of art in their own right.

Eventually our collaboration bore fruit, and the exhibition and book, *Breaking Bounds*, were produced in 1992. As I had hoped, Lois Greenfield was immediately recognized as a formidable *photographer*, and not just a skilled practitioner of one genre – the dance. But Lois has never been one to rest on her laurels, and the intervening years have been a period of intense work and tremendous creativity, to which *Airborne*, which features a selection from recent experiments and collaborations, bears witness.

I

EARTHBOUND

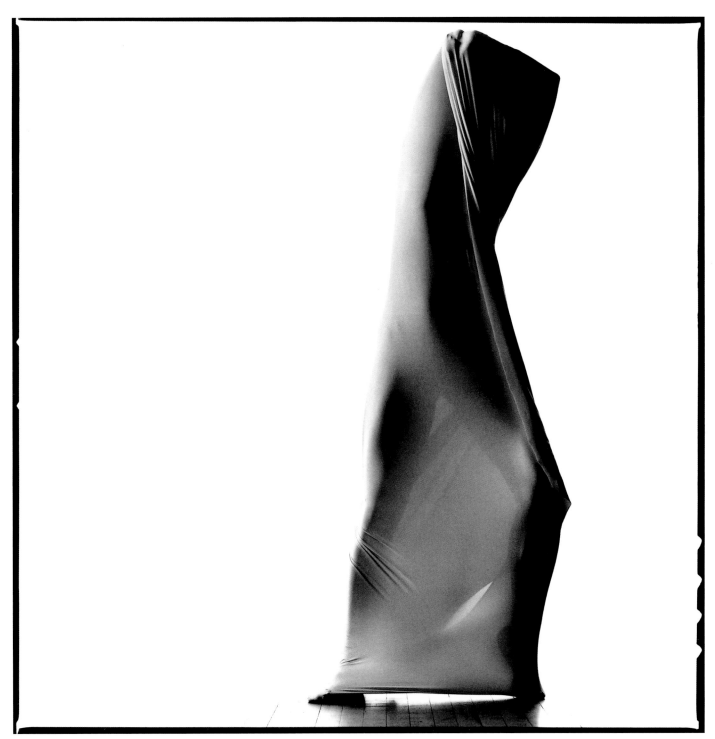

4

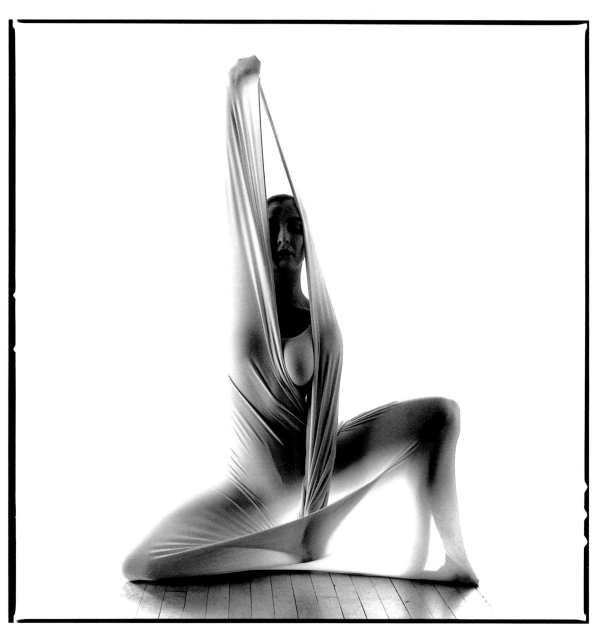

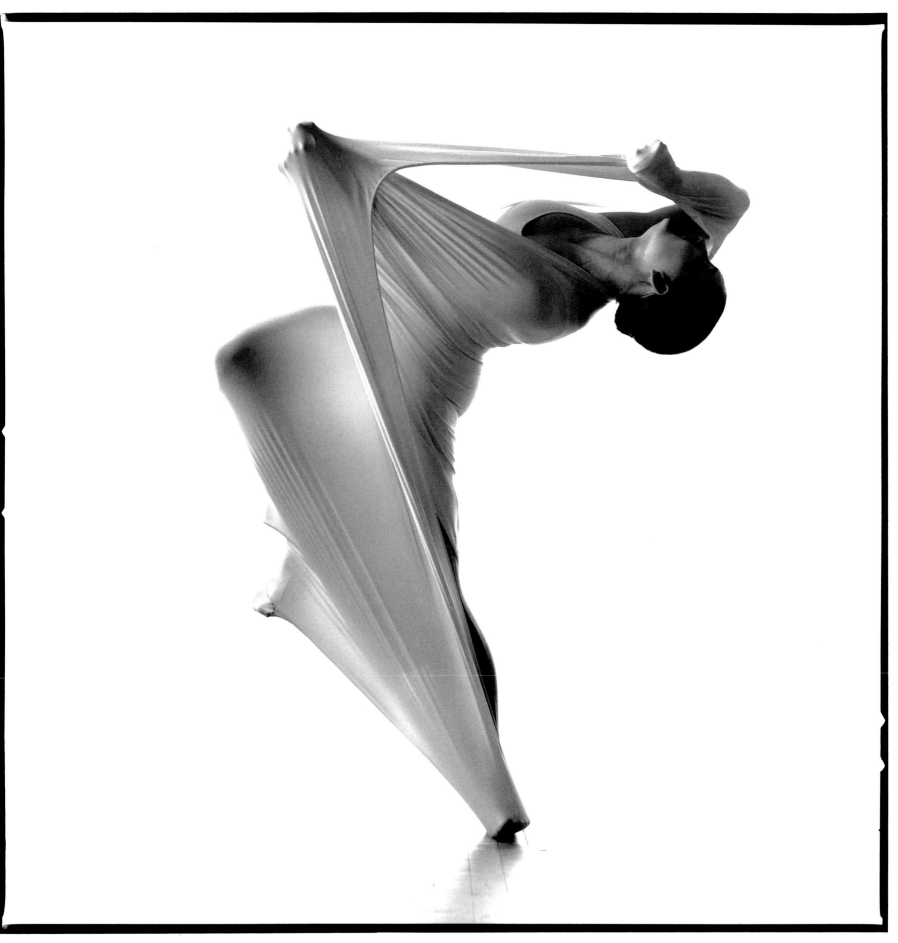

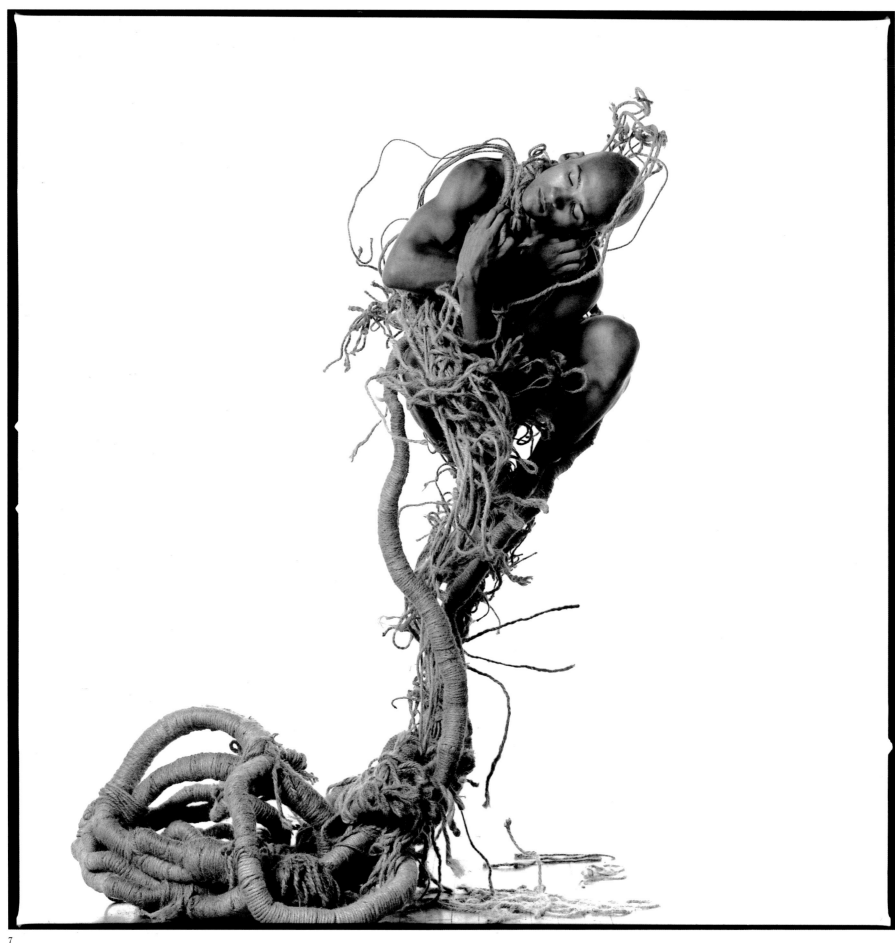

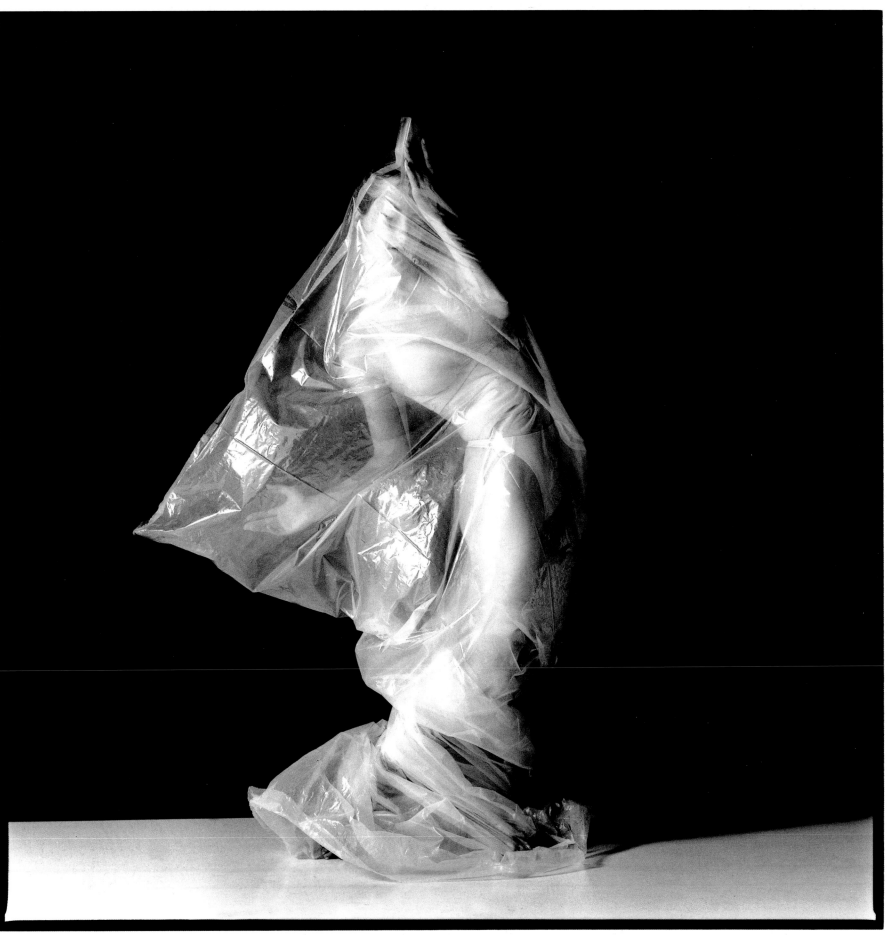

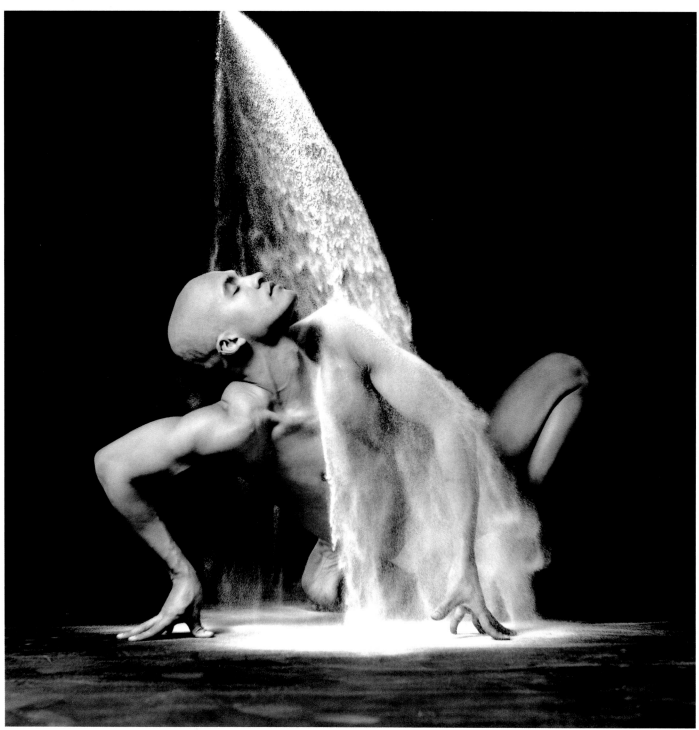

9

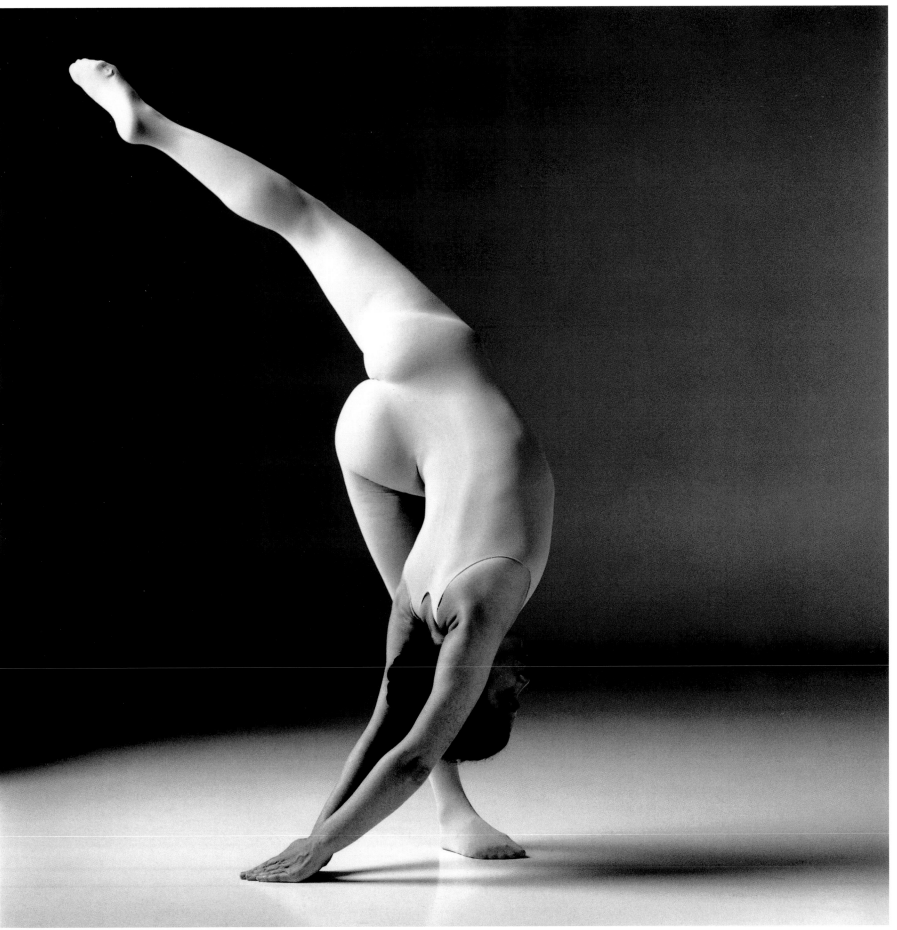

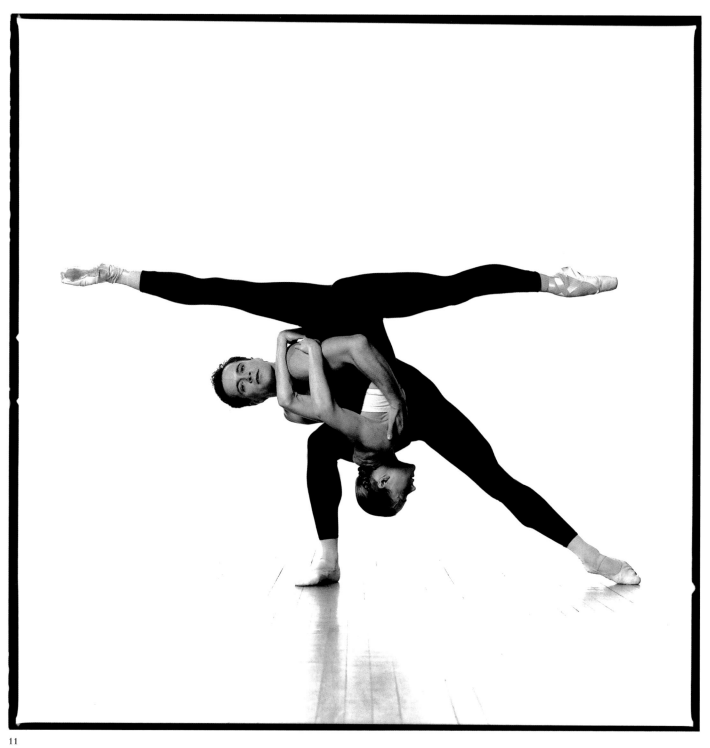

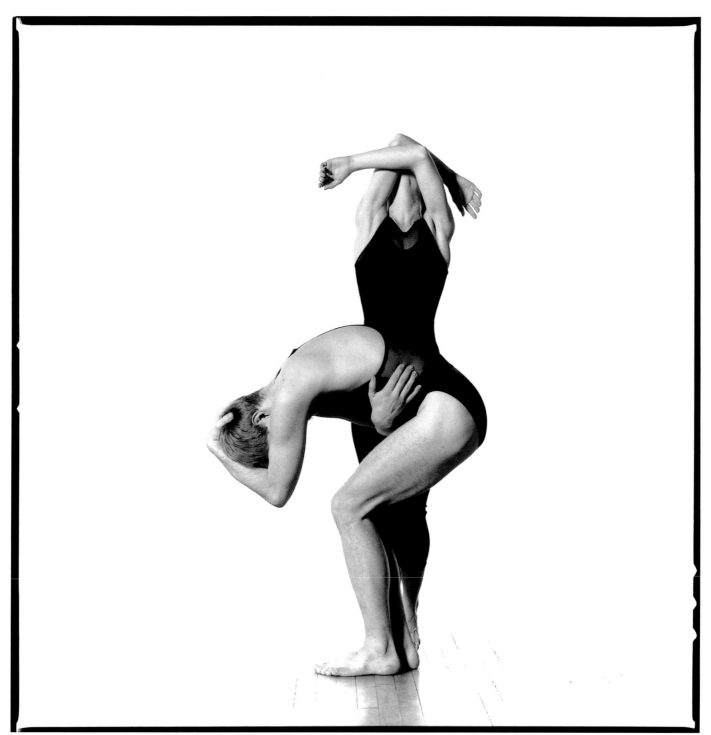

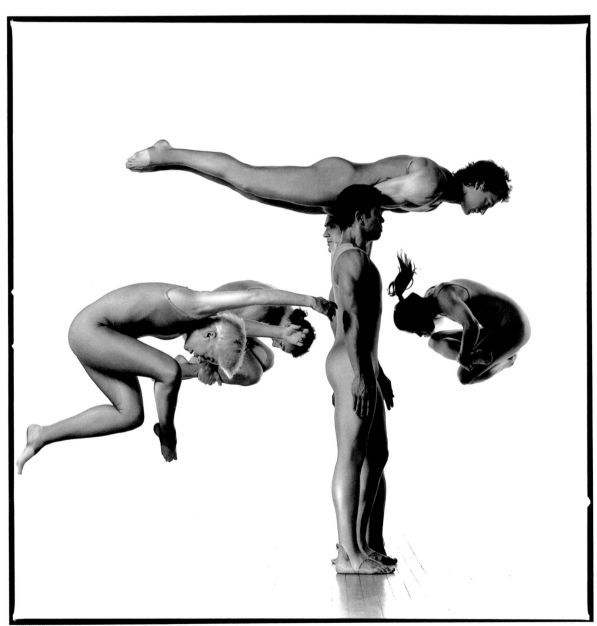

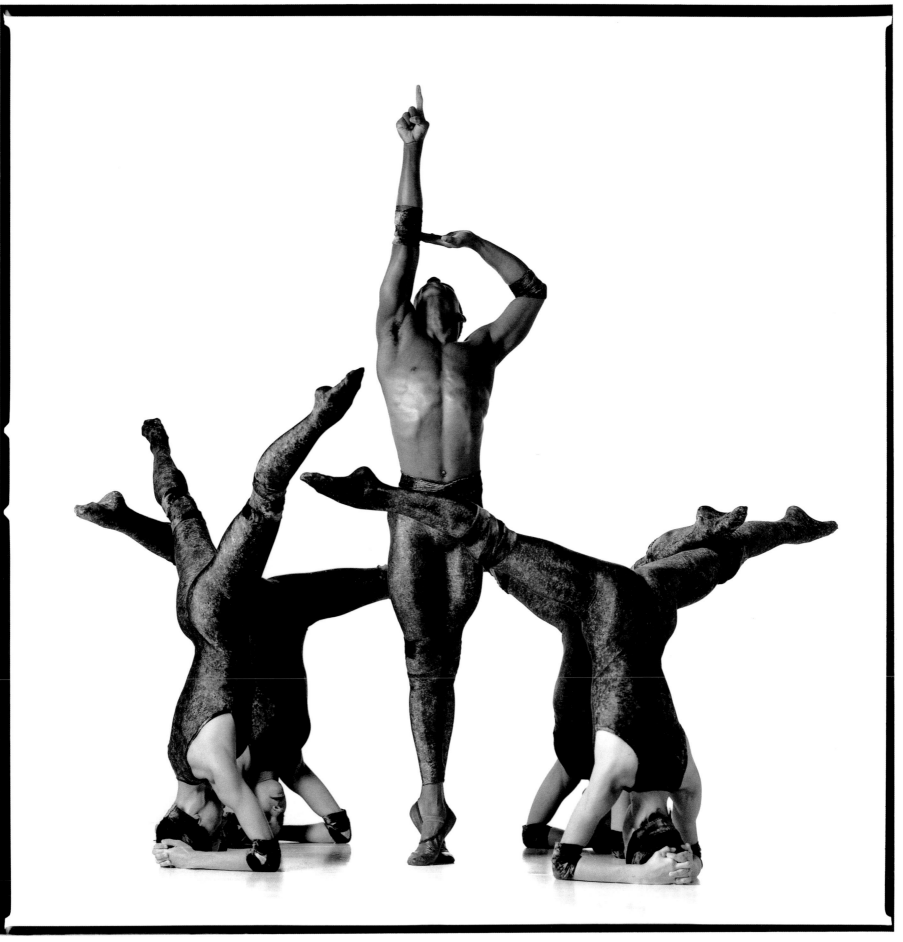

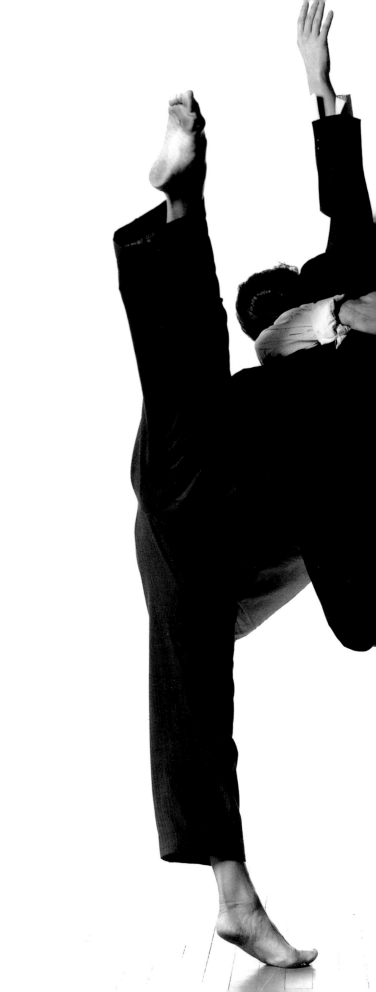

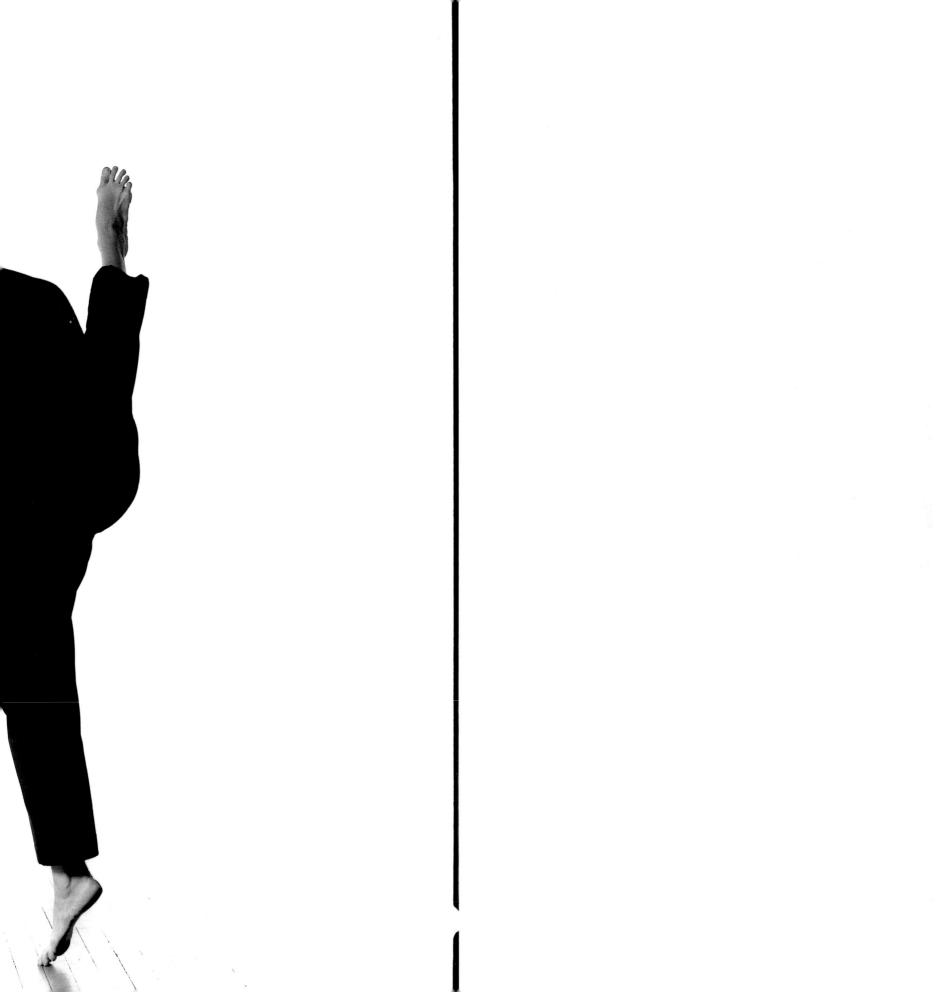

1 Buffy Miller *Chi* **BALLET TECH (Director: Eliot Feld) 1995**
Buffy is so flexible. I doubt that many ballet dancers could twist their torso back in that stretch on the barre. We made sure that the camera was at the right height to accentuate her legs while minimizing her torso. This is a literal choreographic moment.

2 Rika Okamoto,
Kathy Buccellato, Camille M. Brown
MARTHA GRAHAM DANCE COMPANY 1994
We photographed this improvisational moment after a session shooting repertory. We recombined signature movements from Graham dances to make it look like a multiple exposure of one jump seen at three points. I rely on the dancers' ability to visualize their exact position in the air. What is so interesting about working with dancers whose bodies have been formed by a discipline such as Graham's is that however they improvise, they still capture something of the choreographer's distinctive style.

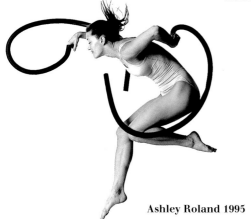

Ashley Roland 1995

3 Chris Harrison, Andrew Pacho, Flipper Hope, Harrison Beal
For Raymond Weil Watches ANTIGRAVITY DANCE COMPANY NYC 1993
It is always a lot of fun to be asked to solve the problem of how to illustrate a concept with pure movement. This photo is from the advertising campaign 'Precision Movements' for Raymond Weil Watches. I had some of my favorite gymnasts – former competitive gymnasts who now have an acroartistic performance company called Antigravity (for obvious reasons) – doing somersaults in a circular formation to evoke the internal workings of watches. They never complained, no matter how many Polaroids I needed to take (we actually only shot a few 12-exposure rolls) because, as Chris says, 'Bruises heal in a day or two, but beautiful pictures last forever.' The maneuver was not especially difficult for such talented performers; the challenge was in coordinating the timing of each gymnast and the height of each somersault so that they would form a circle in the air.

4 Buffy Miller *Frets and Women*
BALLET TECH (Director: Feld) 1992

5 Buffy Miller *Frets and Women*
BALLET TECH (Director: Eliot Feld) 1992
Eliot says that what is essential in photographing his dances in the studio is to find the quality of light that reveals the climate of the dance. In this shot of Buffy, we lit her more from the back to create an evanescent mood. It is always a challenge to adapt a dance intended to be seen in a specific theatrical lighting to the studio, where I don't work with all those special effects. But what I lose in the translation is often compensated for in increased clarity of gesture and form. I love the 'Picassoesque' abstraction of her breast into pure geometry.

6 Buffy Miller *Frets and Women* **BALLET TECH (Director: Eliot Feld) 1992**
Costumes and fabric, as in the case of Barbara Morgan's famous 'Letter to the World' photograph, often tell you where the photographed movement came from. In this photo, however, the taut fabric seems to suggest where the movement will go.

7 Sham Mosher 1993
I invited Sham to come to the studio after I saw a photo in the *New York Times* of one of his site-specific (i.e., outdoor) dances. He brought with him a section of an 800-pound soft jute 'sculpture' he had made, not knowing that I would ask him to jump in it. Not surprisingly, it was hard for him to jump very often with the heavy weight of the sculpture and at the same time keep his face relaxed. Having the dancers erase the inevitable tension in their facial expression is always one of the most difficult things about the process. One reason Sham looks so calm is that I have shot the moment of relaxation after he has reached the peak of his jump and is on the way down.

8 Ashley Roland 1997

Ashley has been one of my primary muses since 1983. After years of photographing her exploding within the frame, I wanted to work with a quieter energy. I used a 'found object' as a prop, as I often do – in this case Ashley suggested an industrial-size plastic bag. She climbed into it and an assistant inflated it with the exhaust hose of a vacuum cleaner. Ashley tied the bag from the inside and danced until the air leaked out.

9 Sham Mosher 1995

I've been working with Sham since 1993 and I have yet to see him perform. Maybe I don't want my imagination curtailed by the specificity of performance and the dancer's notions of self-representation. In this shot, what is being poured over him is a mixture of sugar and flour coming down through a tube above his head. The granularity of the sugar minimized the dust left in the air from the flour and made the powder flow more smoothly. Sham describes the sensation as 'quite soothing, like being bathed in a dry waterfall'.

10 Maureen Fleming 1997

At a stage performance or dress rehearsal I was often frustrated by the audience's fixed position, seeing a dance from only one perspective. In the studio I always walk around the subject to find the best angle from which to photograph. With Maureen, it is hard to choose just one perspective. In this shot I rotated her position vis-à-vis the front. Maureen found this perspective more surreal and changed her choreography to match my photographs.

11 Lynn Aaron, Jeffrey Neeck *Common Ground*
BALLET TECH (Director: Eliot Feld) 1991

This is a literal choreographic moment from *Common Ground.* As usual, I photographed this piece without seeing it beforehand. When I did see it on the stage, after living with the photo for a long time, I couldn't believe how fast that moment went by.

12 Bronwen MacArthur, Lewis Bossing *Landings*
GINA GIBNEY DANCE 1993

13 Jude Woodcock, Rebecca Jung,
Adam Battelstein, Kent Lindemer,
John Mario Sevilla, Sebastian Smeureanu
PILOBOLUS 1992

The day I shot this, we were concentrating on counterbalance and weight-sharing moments. The ideas for these improvisational sessions come very fast while we are working. By the time we wait thirty seconds to see a Polaroid of one idea develop, we are already trying something else. Sessions like these develop a momentum of their own that seems to carry us along. Adam likened the experience to 'being possessed by something with wings that is headed for a flame. After what seems like a brief moment, everything crashes to the floor in a heap of costumes and ashes and one remembers almost nothing.'

14 Darren Gibson and Company *Ogive*
BALLET TECH (Director: Eliot Feld) 1995

I first photographed Darren when he auditioned for Eliot Feld's New Ballet School (now called Ballet Tech) in 1979 when Darren was ten years old. Eliot created the school twenty years ago to locate and nurture children in the New York City public school system who have a gift for dance. Darren later joined the Feld Ballet, now known as 'Ballet Tech', becoming one of the company's leading soloists and ballet master.

15 Veronica De Soyza, Margarita Guergué *Constanza* MARGARITA GUERGUÉ 1993

I was on assignment from the *Village Voice* to photograph Margarita's current programme. When I showed her the first Polaroid from the dance *Constanza*, she declared the moment 'an accident', which would never happen again. The picture here is the closest we could get to duplicating that initial 'mistake', where, due to the dancers' position, their torsos and hands disappeared in such a way that there was no trace of the bodies attached to the legs. The fact that we couldn't duplicate the moment exactly pleased me because it confirmed the uniqueness of every photograph.

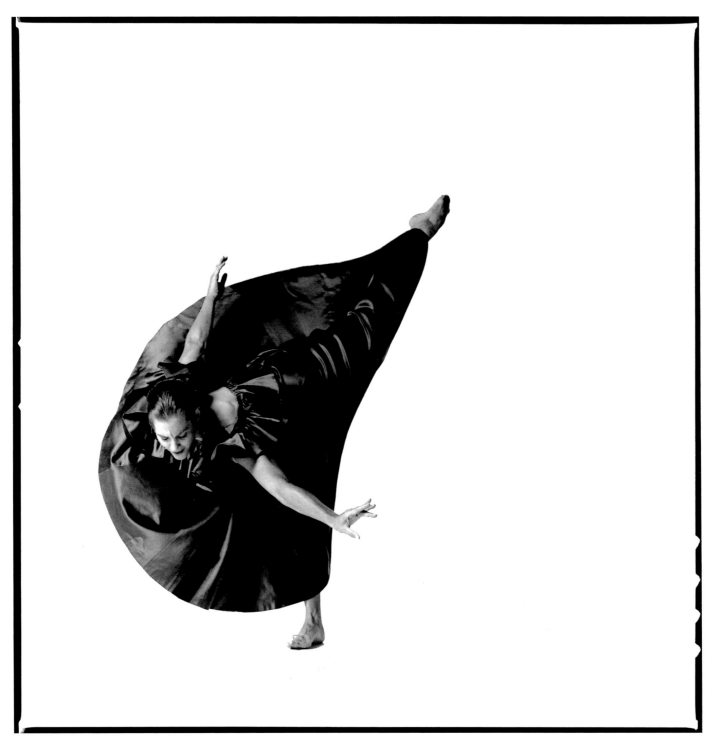

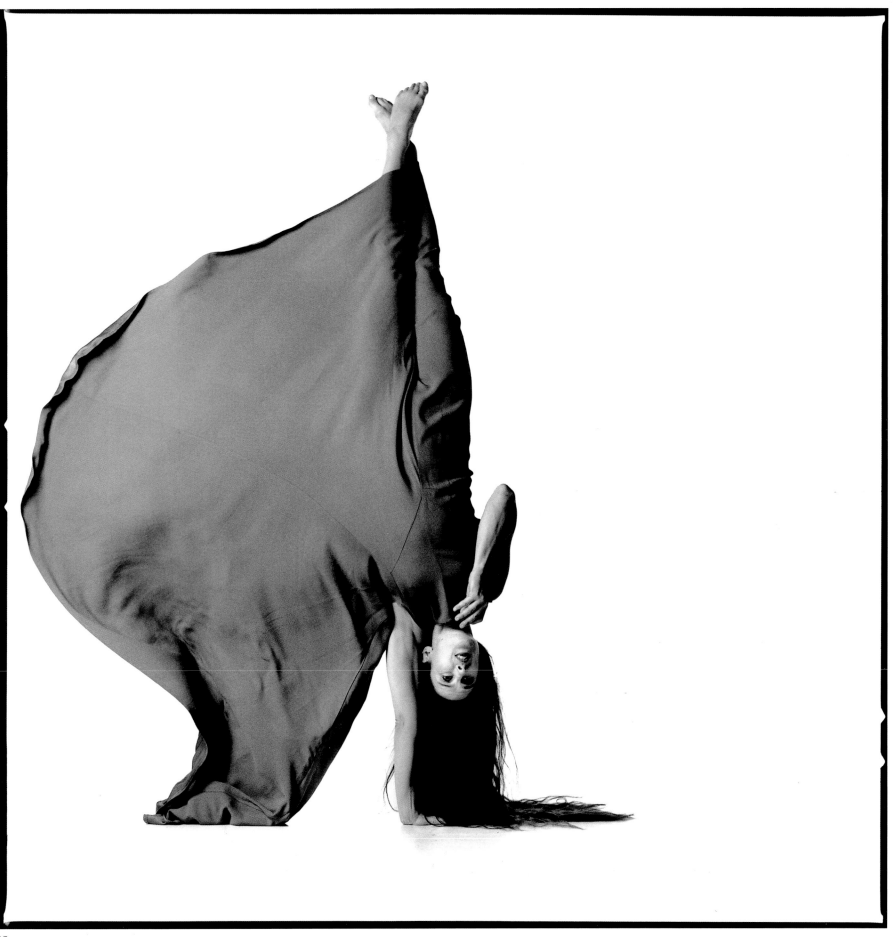

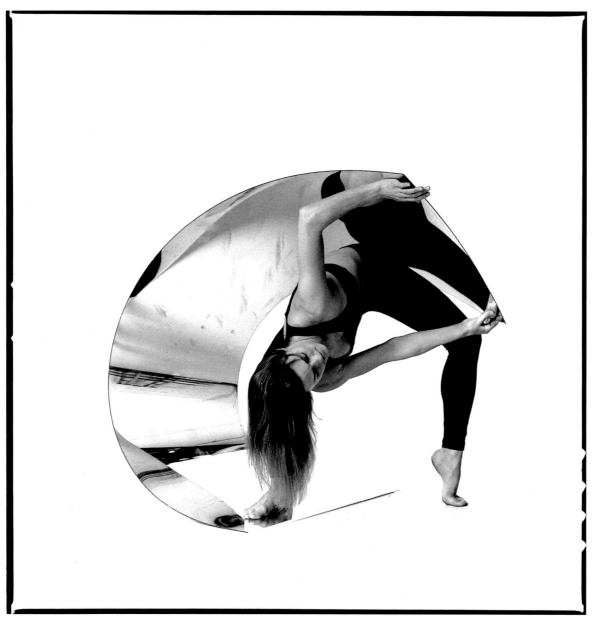

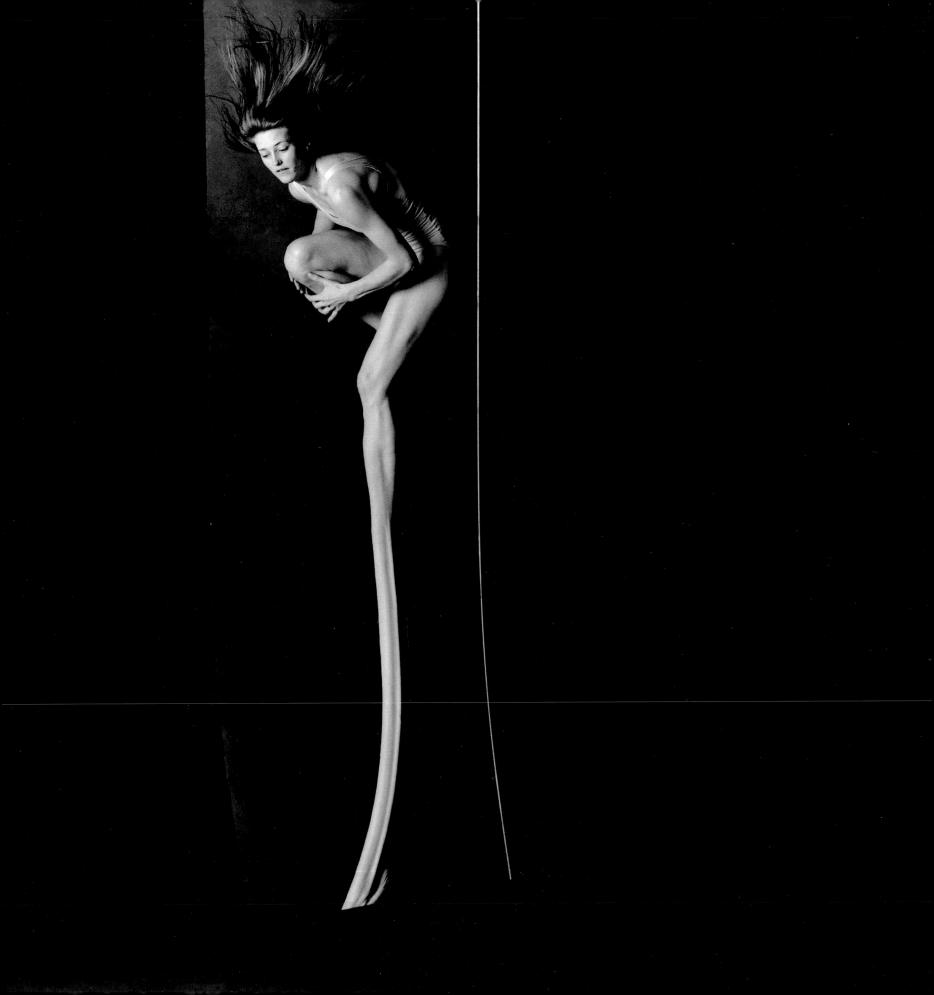

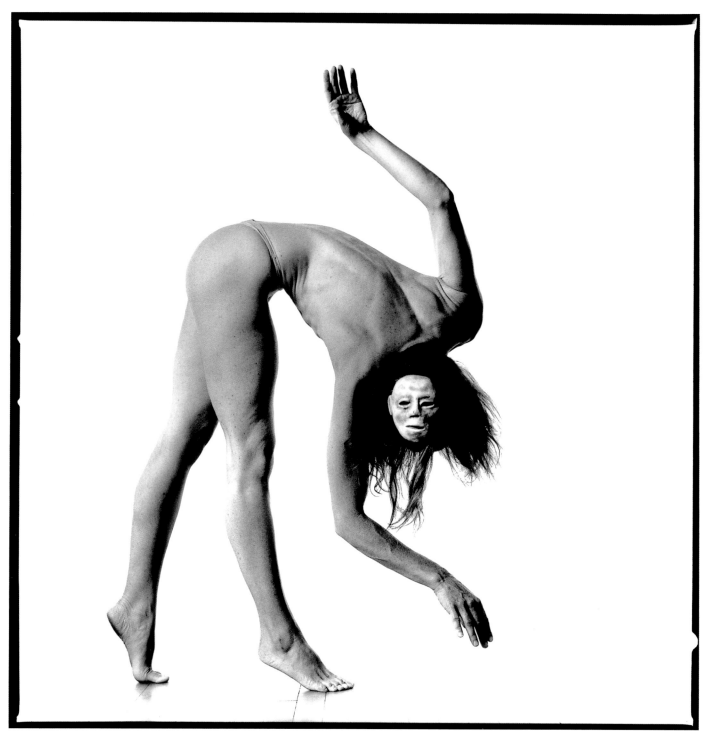

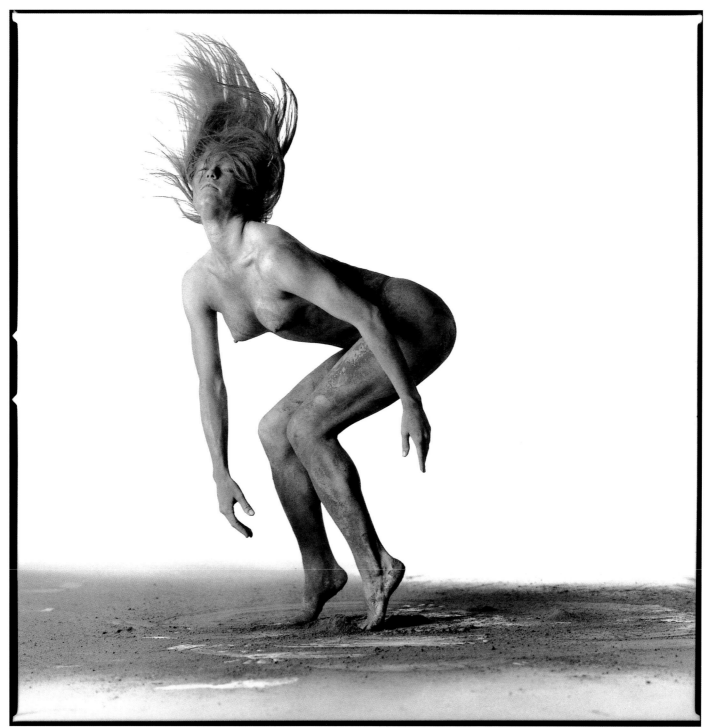

21

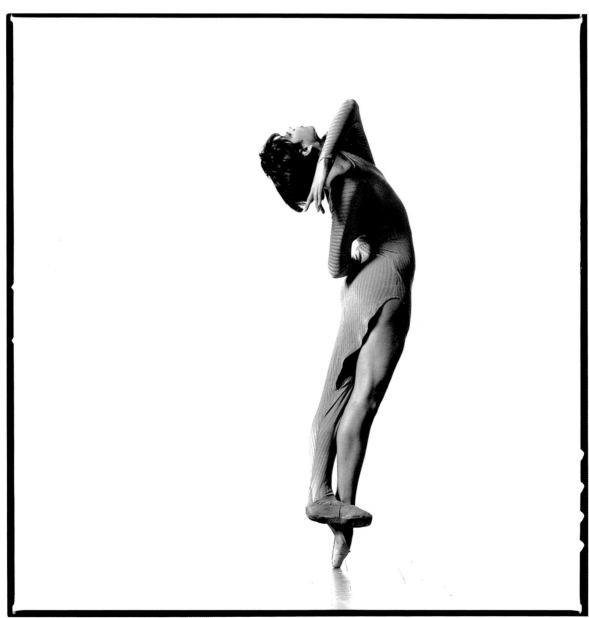

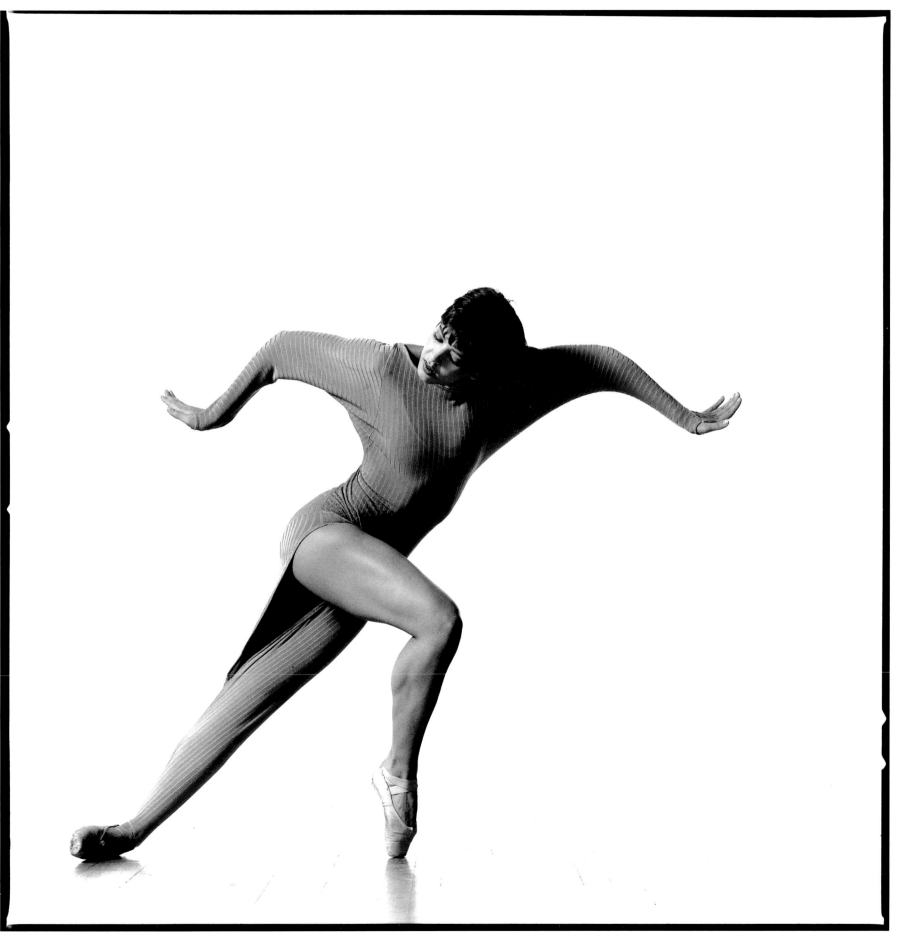

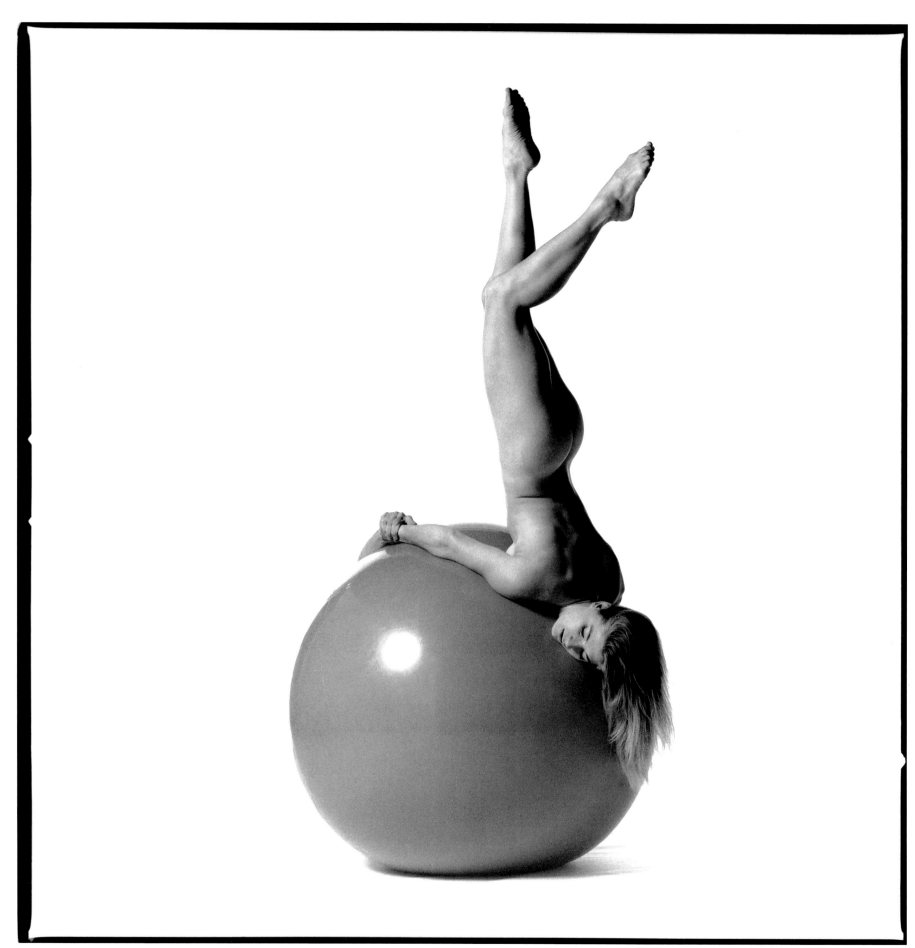

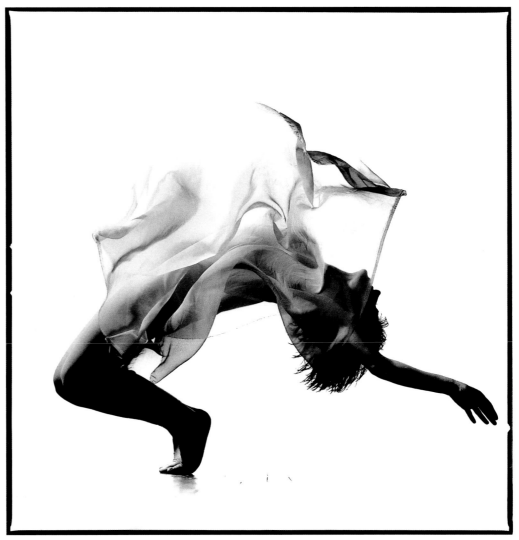

25

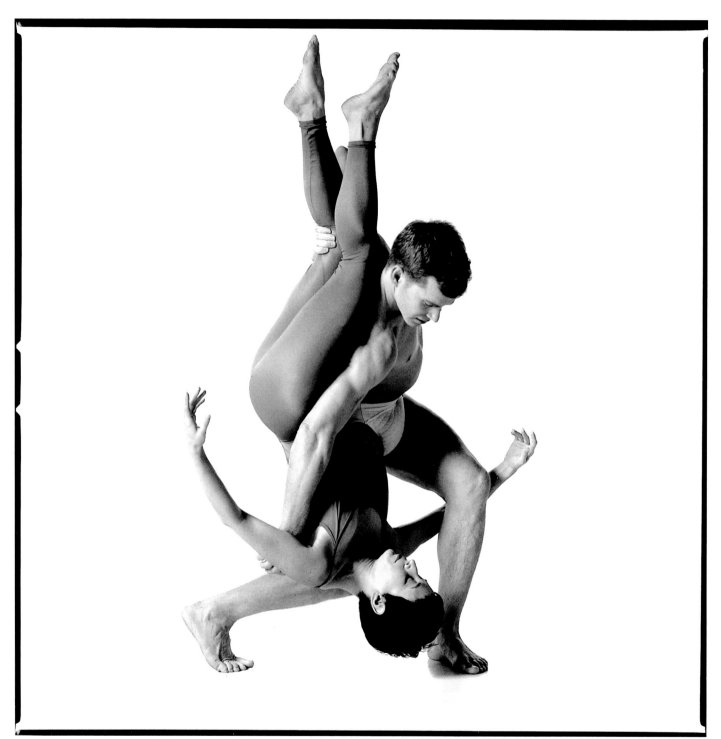

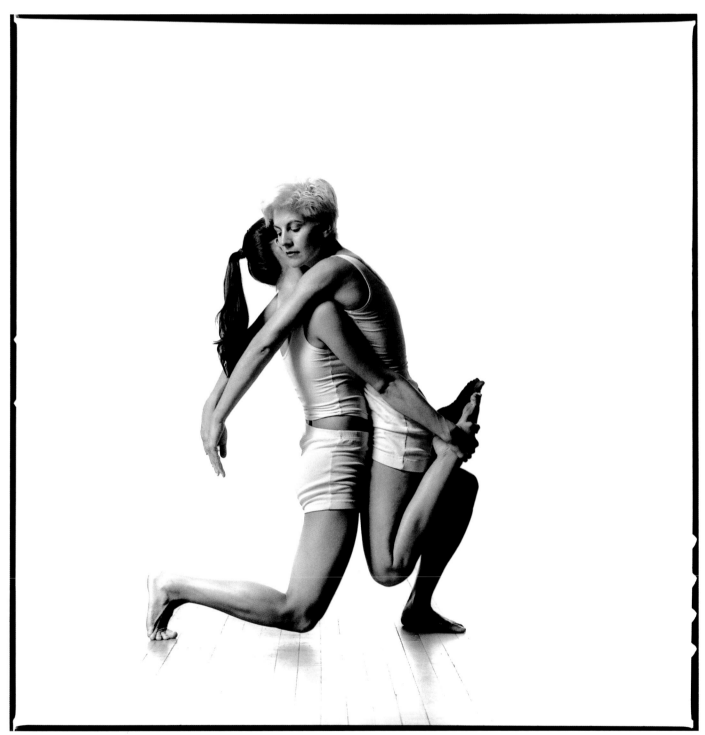

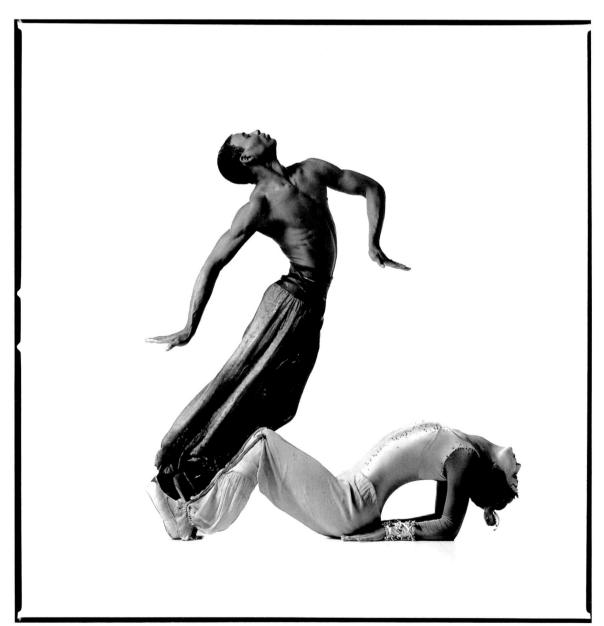

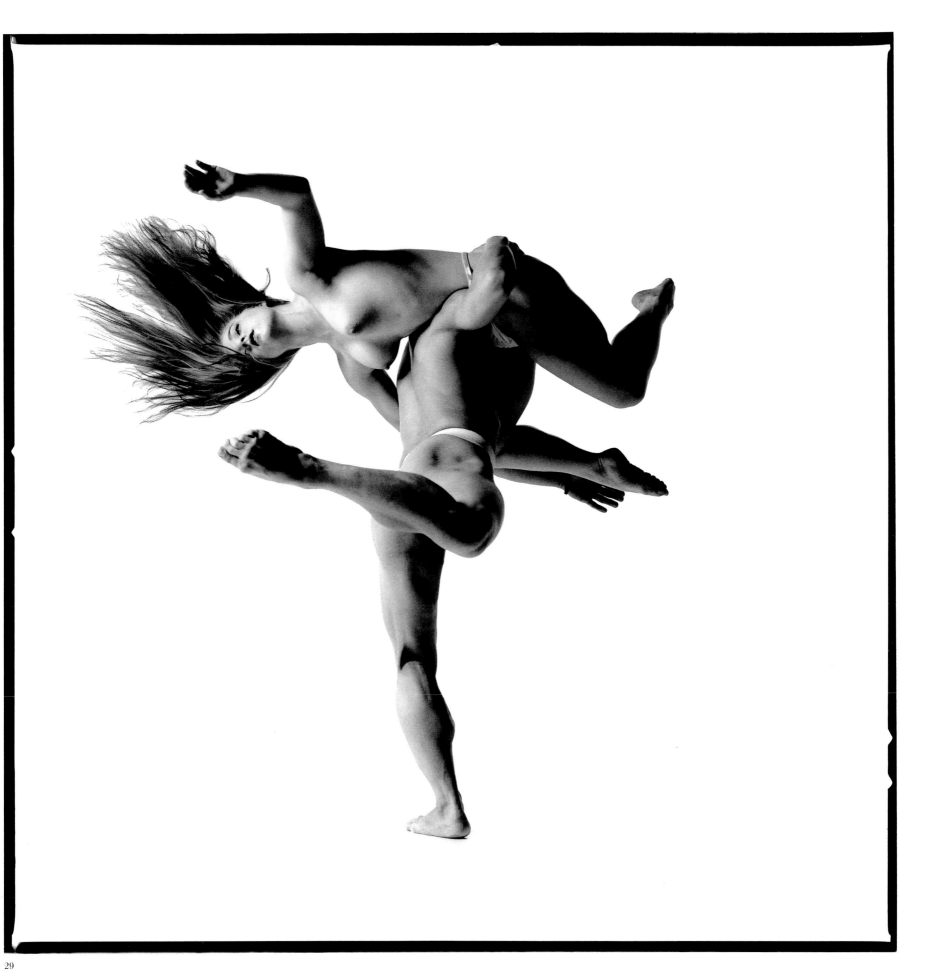

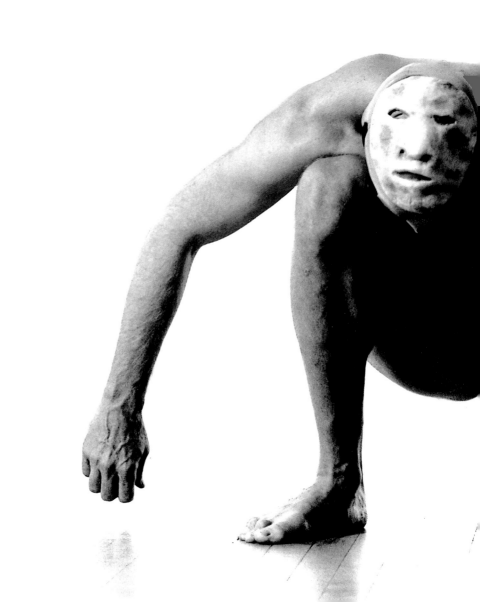

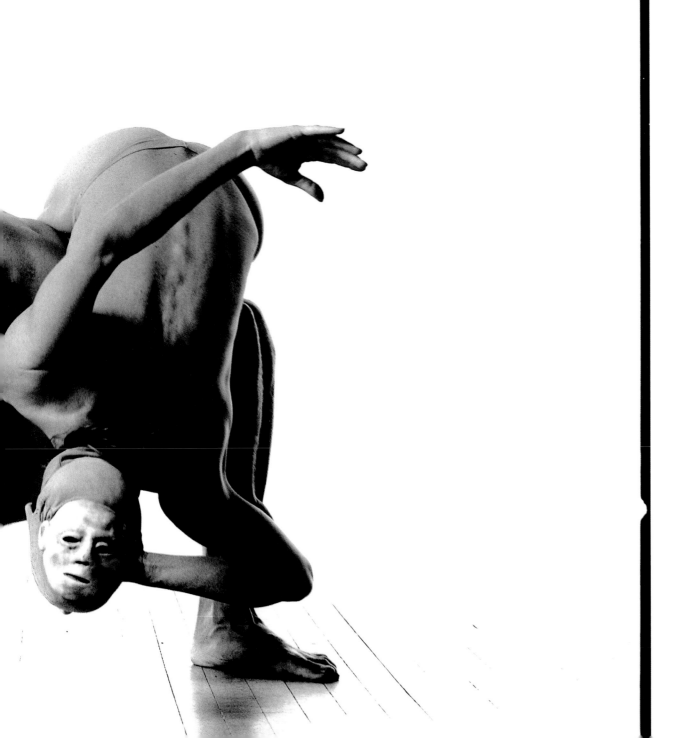

16 Denise Vale
MARTHA GRAHAM DANCE COMPANY 1994

17 Margie Gillis 1995
Margie's costumes always take on a movement dynamic of
their own. In this case the force of Margie's legs thrown into the air must
have sent her dress all the way to the other side, giving the illusion that the
dress was solid and was supporting her one-armed handstand.

18 Ashley Roland 1994
The strip of mylar in which Ashley has coiled
herself has become a staple studio prop which I use
to reflect, distort or erase. This was the first time we
decided to bend the mylar and have Ashley use
it not only as a prop, but as a partner.

19 Ashley Roland 1995
We set up the mylar strip vertically on top of the black
background paper and tipped it to elongate only Ashley's legs, blacking
out the area of the studio that would have been reflected in the mirror.

20 Paola Styron Guardian Spirit from *Moonskin*
Masks by Robert Faust FAUSTWORK MASK THEATER 1993
I first worked with Robert when he was a member of Pilobolus. After seeing
Robert and Paola perform with their masks at a Friends in Deed AIDS benefit, I
invited them to come to the studio. Robert brought a lot of masks, all of which he
had made. Paola usually performs this character of a guardian spirit in black
clothes and a hood. I mostly avoid costumes, preferring the abstraction of an
almost naked body. As a result of these photos, they now often
perform *Moonskin* without clothes.

21 Ashley Roland 1995
I wanted to create a dark powder counterpart
to the shots of Sham Mosher taken with the flour
(plates 9 and 58). The cocoa didn't pour as well as
the flour and sugar mixture, so we used the cocoa
as a costume for Ashley. We were vacuuming cocoa
dust off the floor for weeks after the shoot.

22 Geralyn DelCorso
***Frets and Women* BALLET TECH**
(Director: Eliot Feld) 1992

23 Geralyn DelCorso *Frets and Women*
BALLET TECH (Director: Eliot Feld) 1992
Unlike most ballet choreographers, Eliot enjoys
transitional movements. We really 'stretched'
this moment to accentuate the feeling of being
anchored and trying to pull away.

24 Andrea Weber *Diana and the Moon*
(Choreographer: Suzie Scherr) 1991
It wasn't easy to get Andrea to stay balanced, with most of her weight over
on one side of the ball. She is actually being supported by her brother, who is
clasping her hand and crouching behind the ball. This image is my only nude.

26 Robin Shevitz, Russell Aubrey
A Fork in the Road
CAROLYN DORFMAN DANCE COMPANY 1995

27 Jude Woodcock, Rebecca Jung *Duet 92*
PILOBOLUS 1992

28 Darren Gibson, Patricia Tuthill *Asia*
BALLET TECH (Director: Eliot Feld) 1996
In this shot, we exaggerated the gestures, as we usually do, so that they will make
a more exciting still image. I always try to stretch the 'moment' to the last fraction of a
second (before the dancer falls out of position), to avoid the picture looking posed.

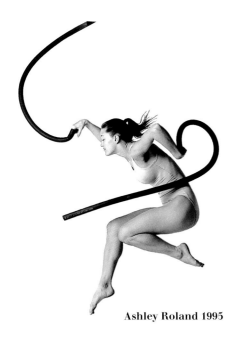

Ashley Roland 1995

29 Morgan Keller, Arthur Aviles 1994
Arthur added so much energy and creative ideas
to all my sessions with the Bill T. Jones/Arnie Zane dance
company that I was very excited to work with him after he went
off on his own. He brought a friend, Morgan Keller, with him and
we played around with no set plan in mind. When I look at the
picture now it reminds me of an Italian Renaissance
sculpture of a mythological 'rape' scene.

25 Gail Gilbert *Cirrocumulus* **1993**
Gail is the third generation of dancers with whom I have worked.
In the early 1970s I was cutting my teeth on classic modern dance
companies such as Paul Taylor. In the early eighties I started my very
influential collaboration with one of Taylor's main dancers, David Parsons.
In the nineties I am working with one of David's descendants who is
now doing her own work. Here we are playing with a simple, sheer
scarf which she uses in a series of dances based on cloud formations.

30 Robert Faust, Paola Styron
Messengers from *Moonskin*
FAUSTWORK MASK THEATER 1993

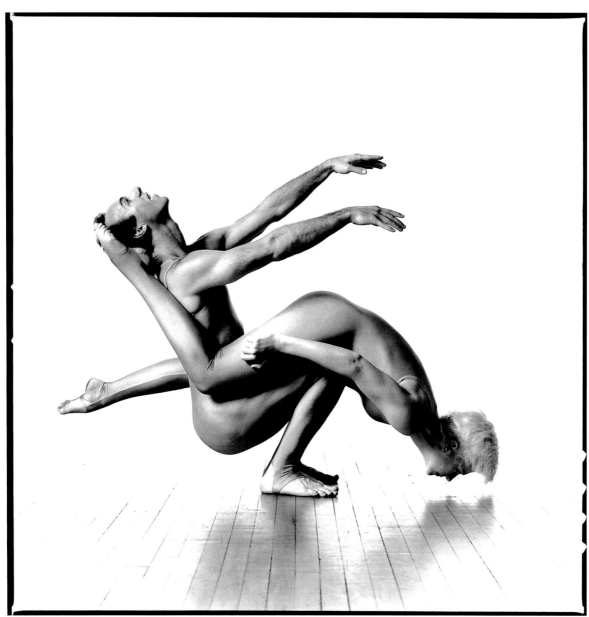

31

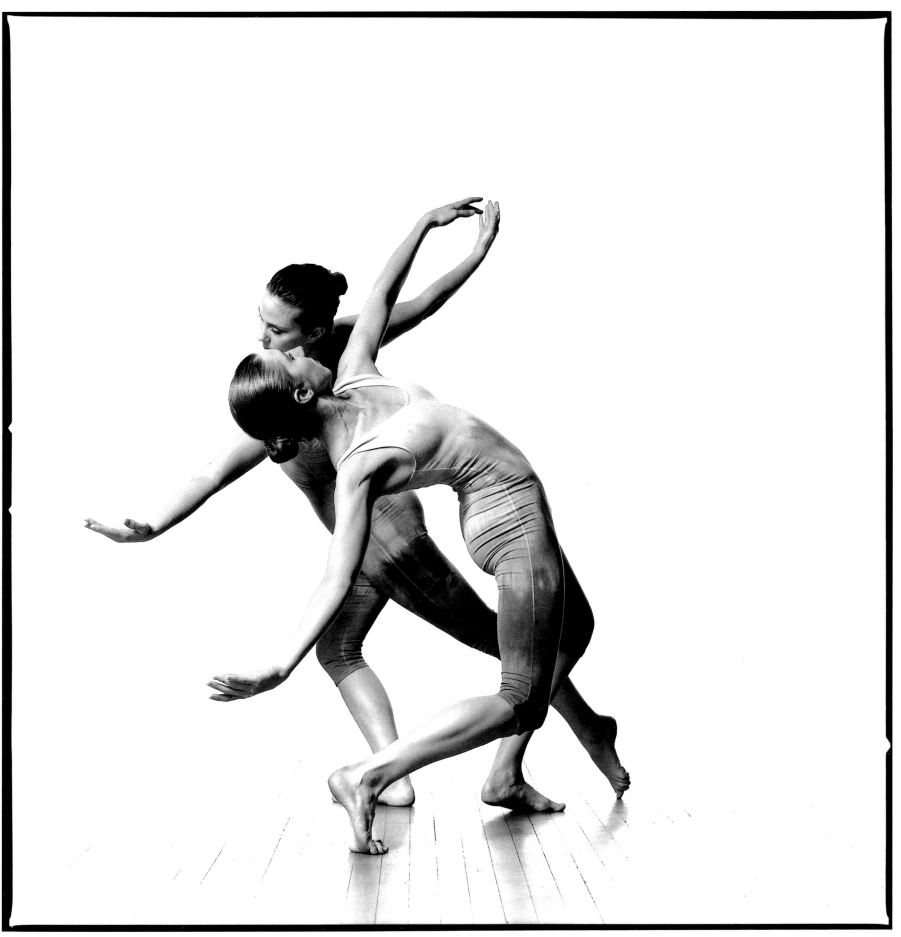

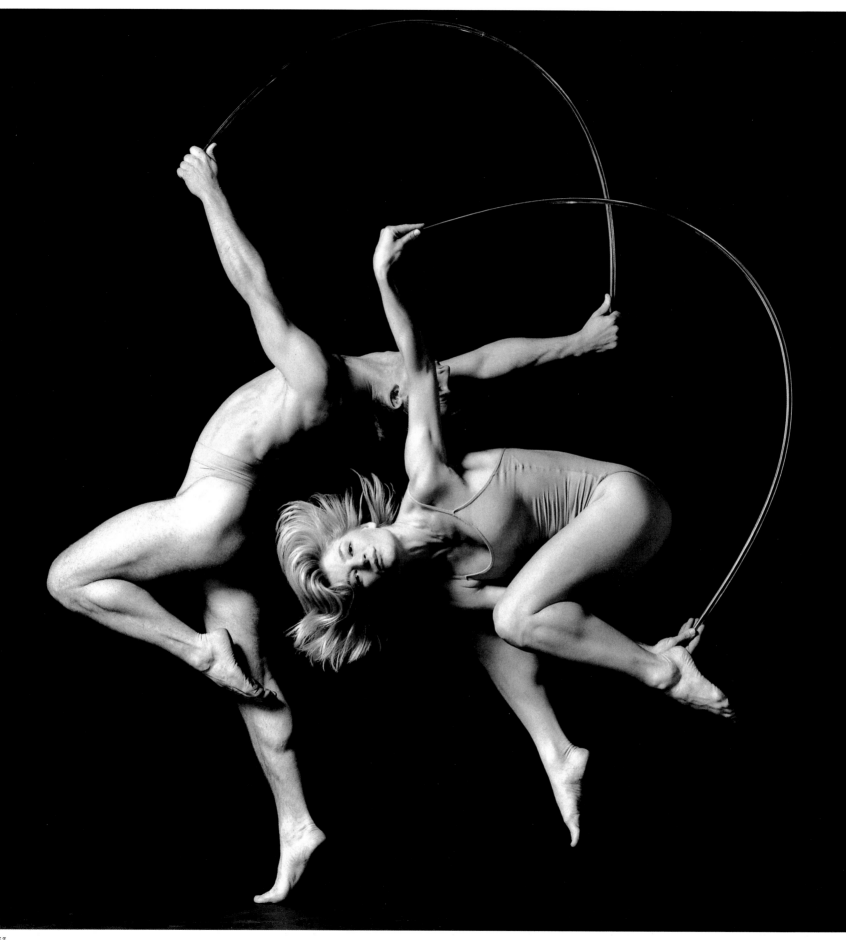

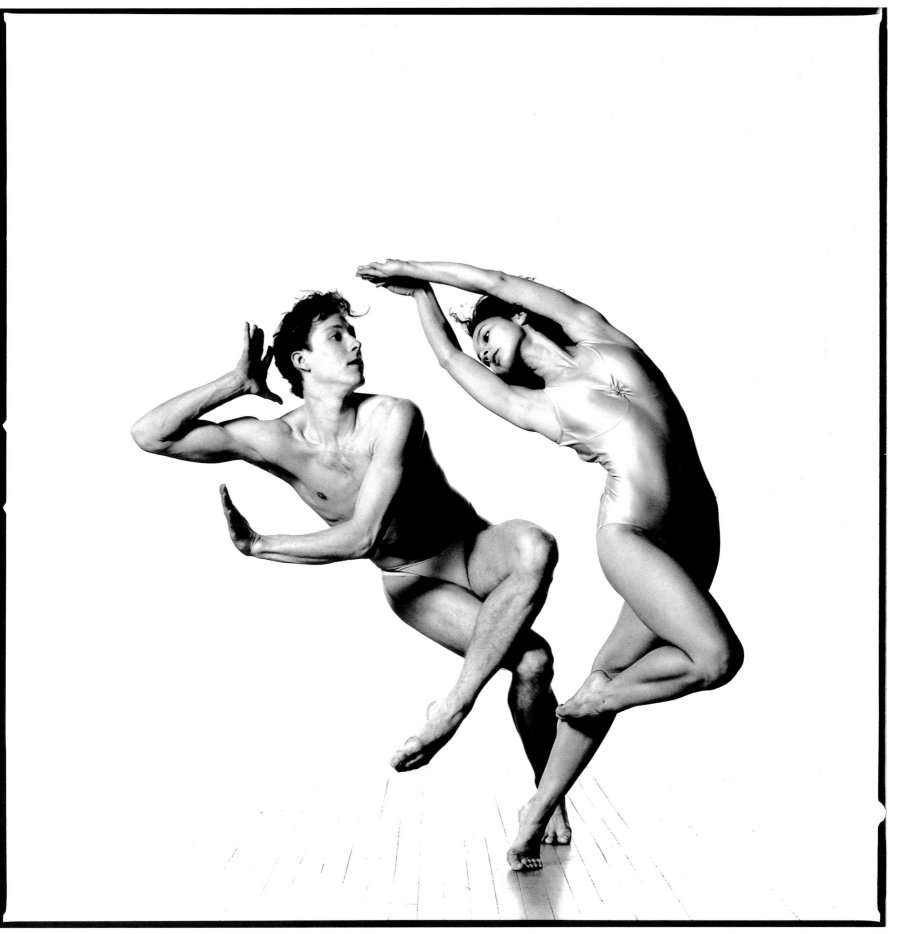

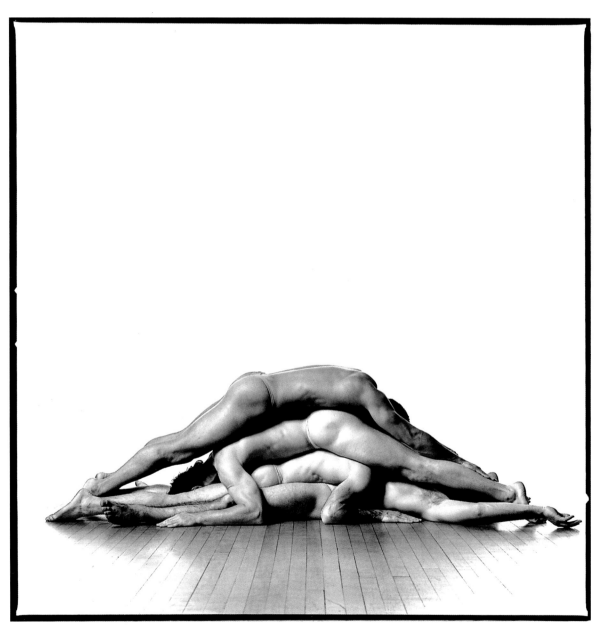

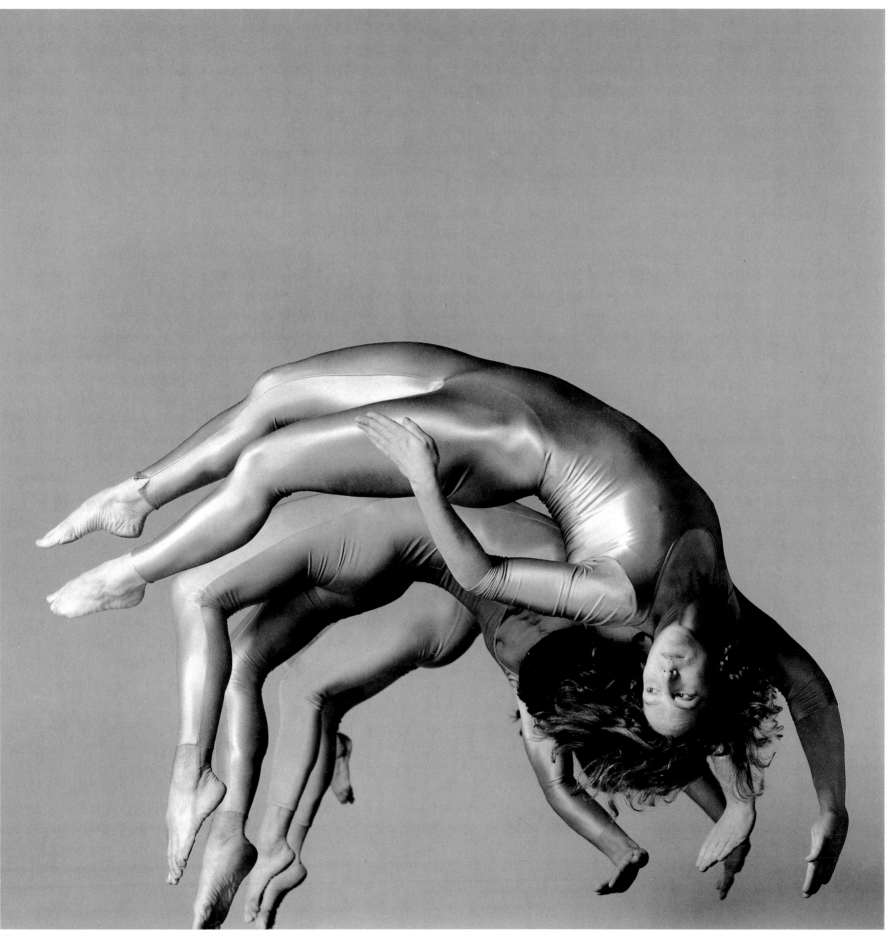

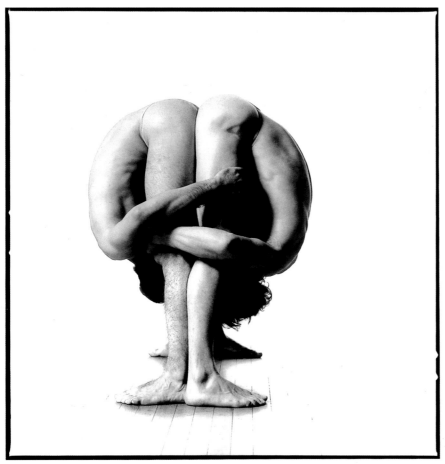

37

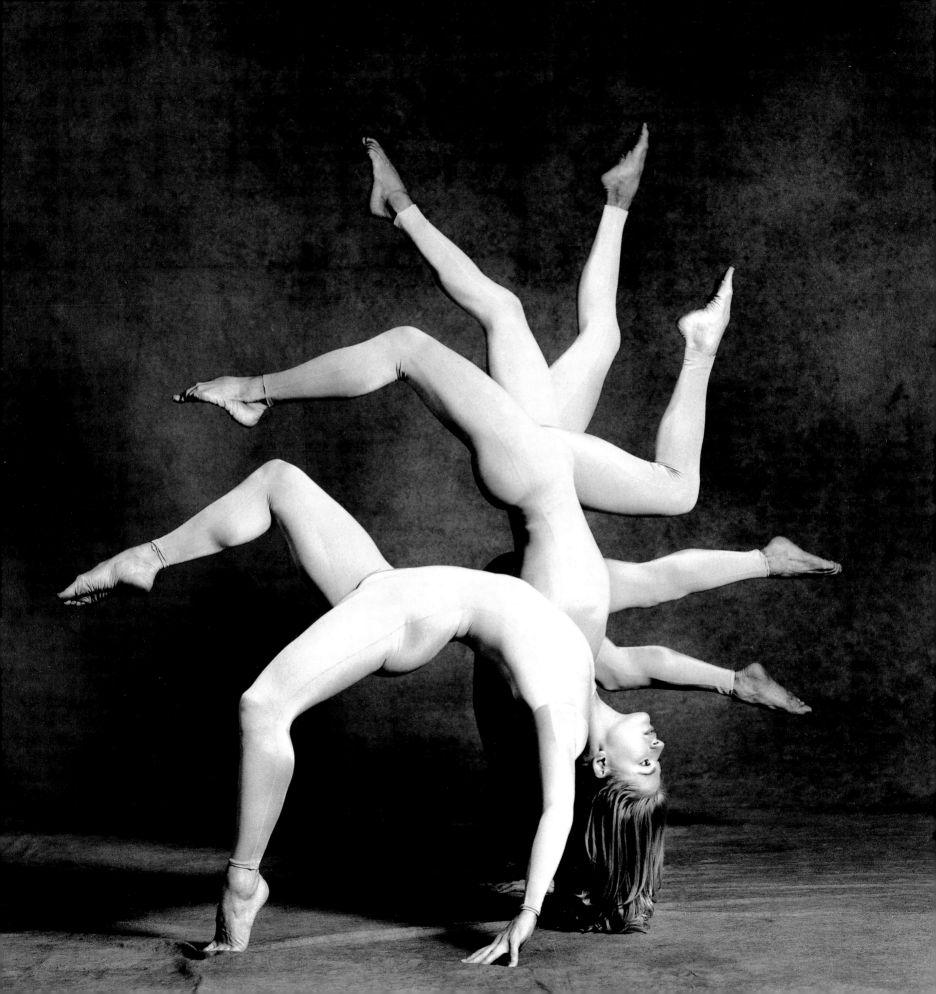

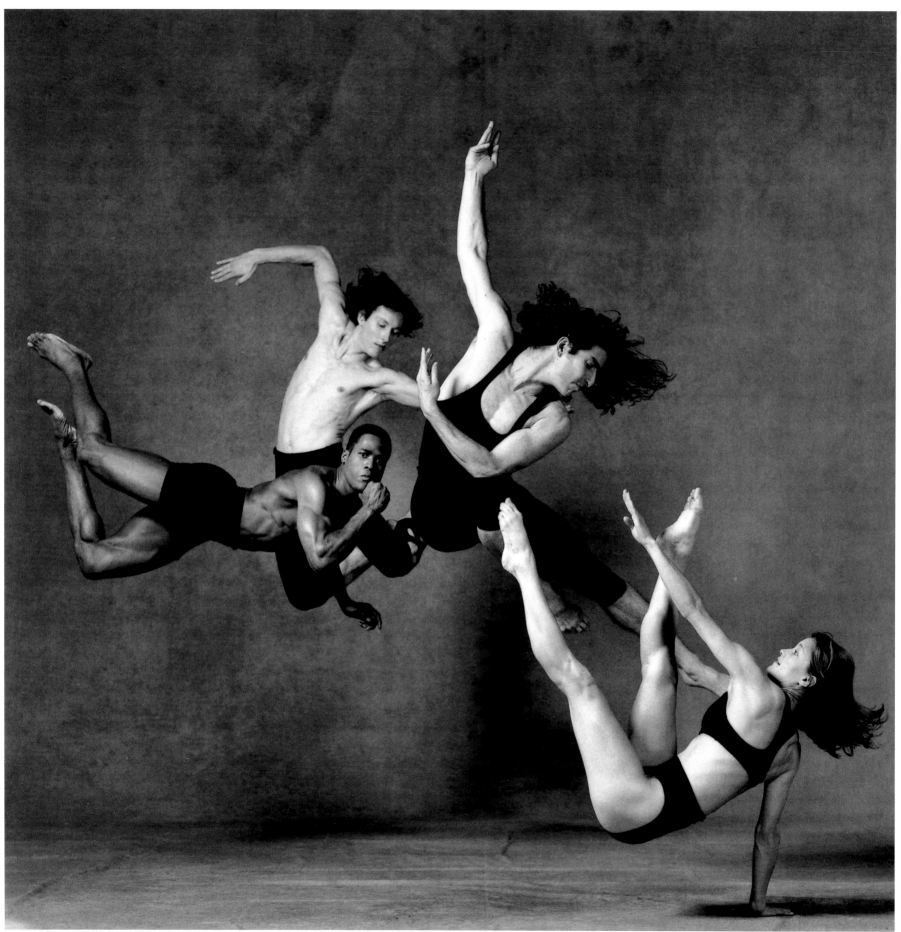

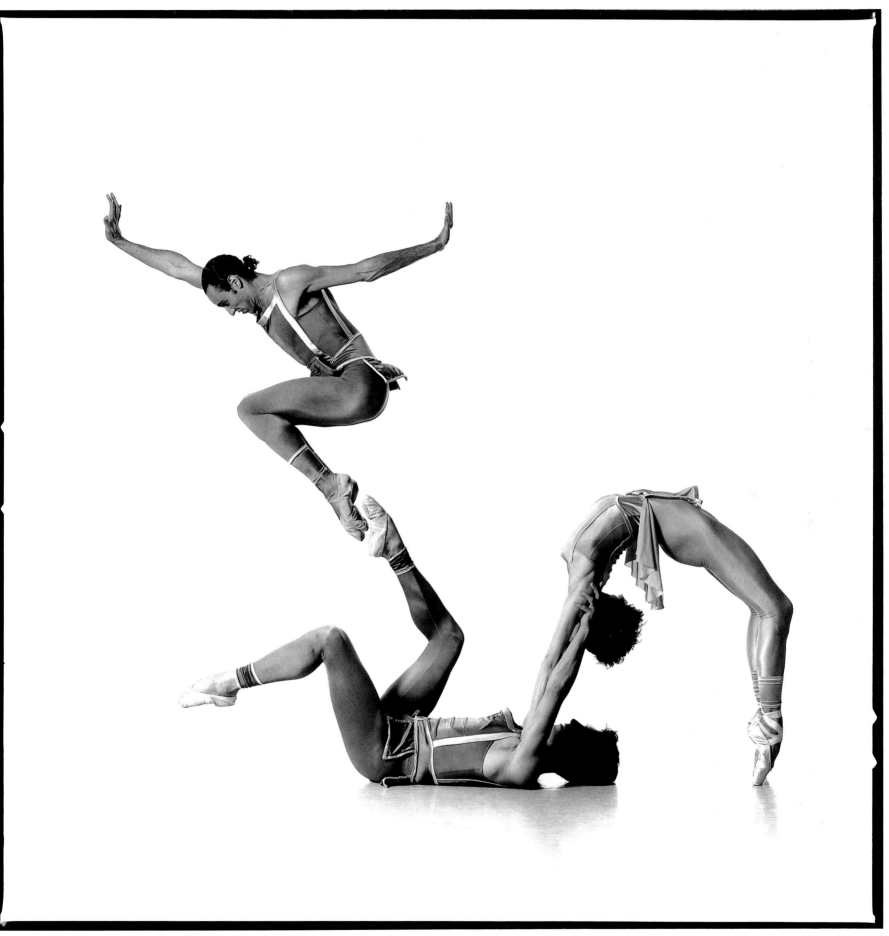

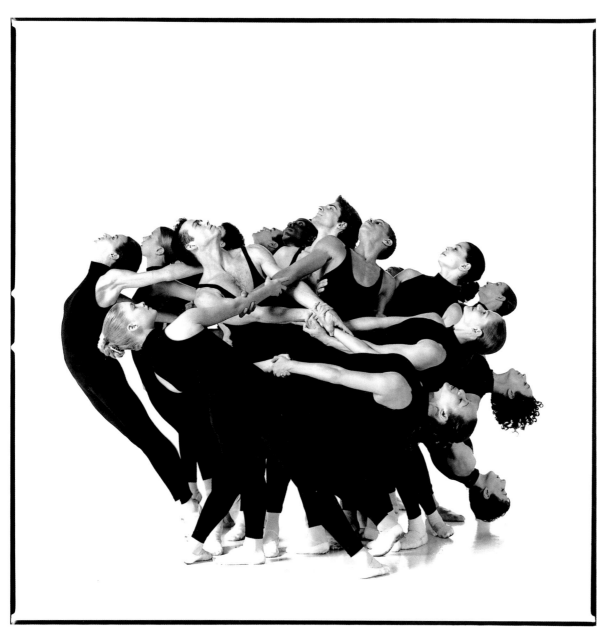

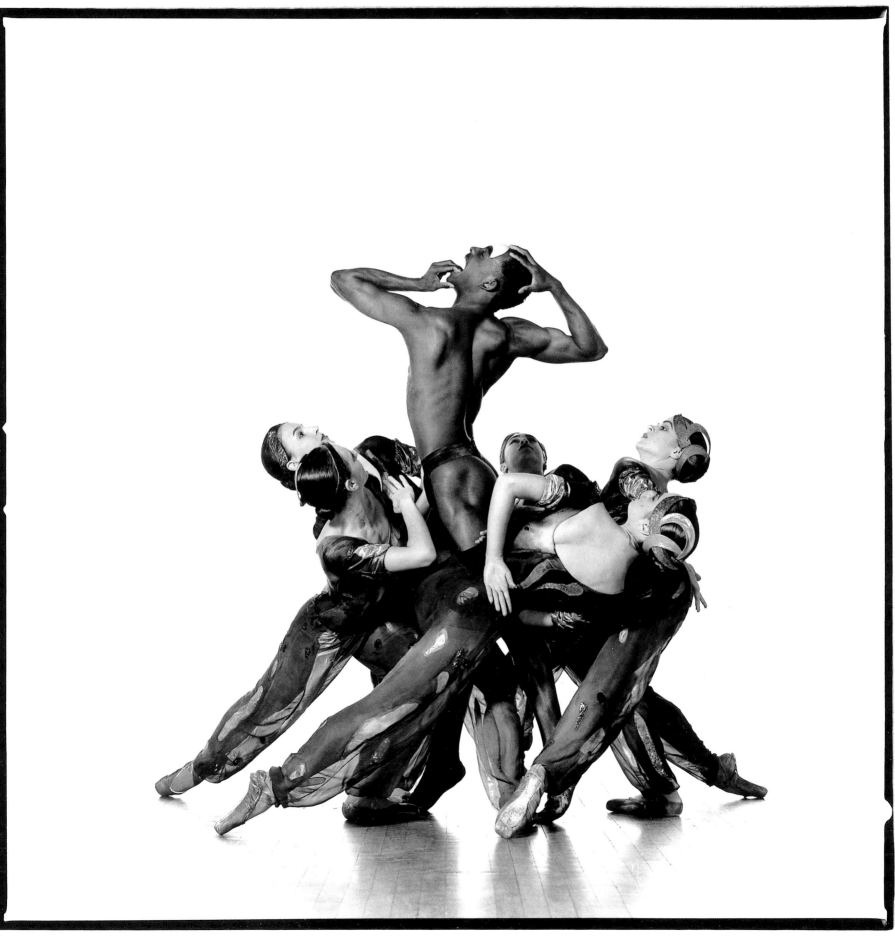

II

AIRBORNE

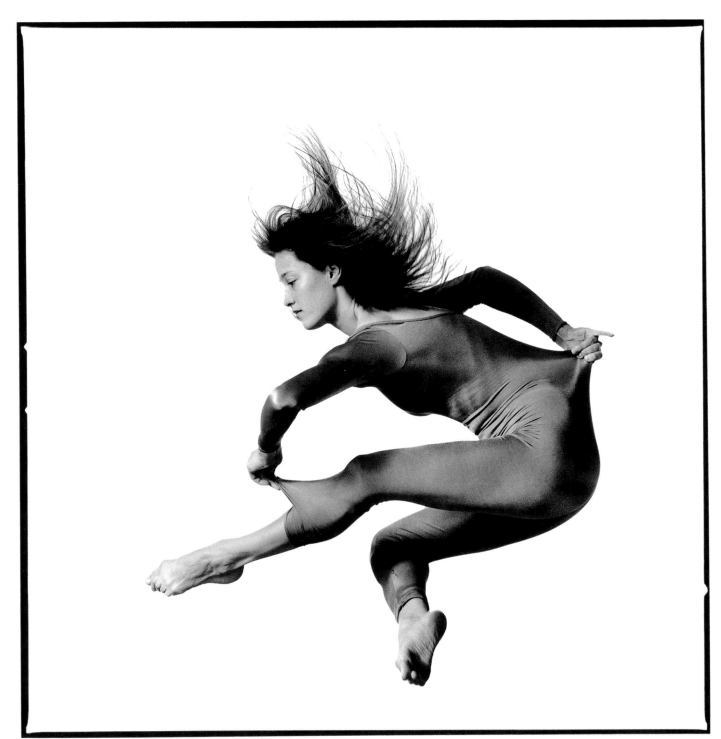

43

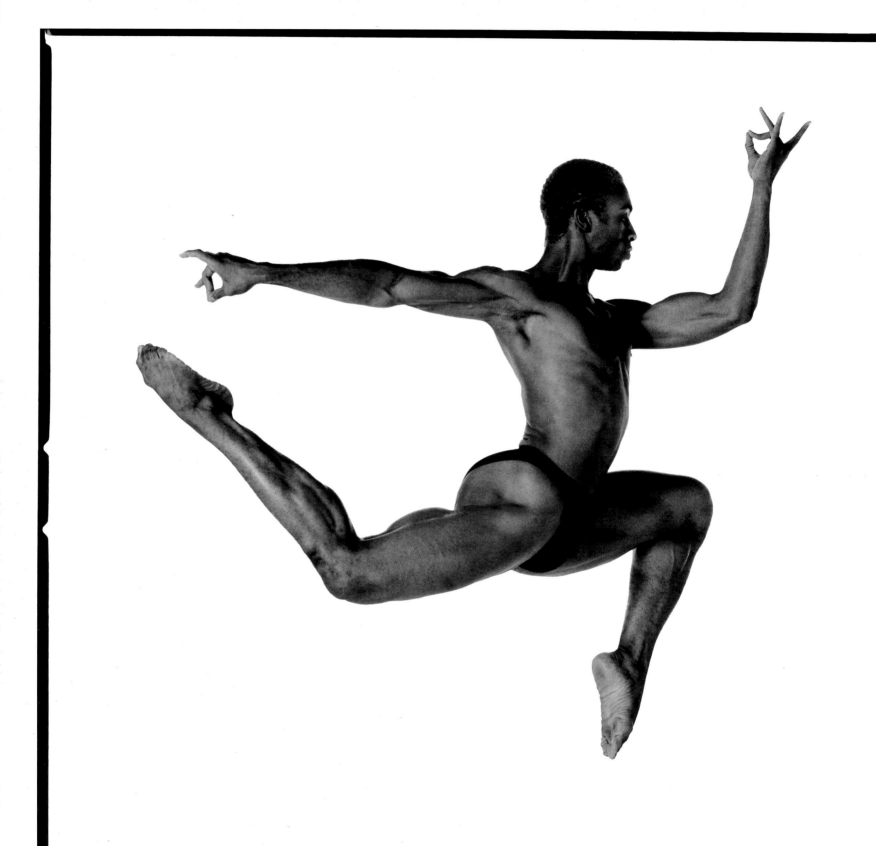

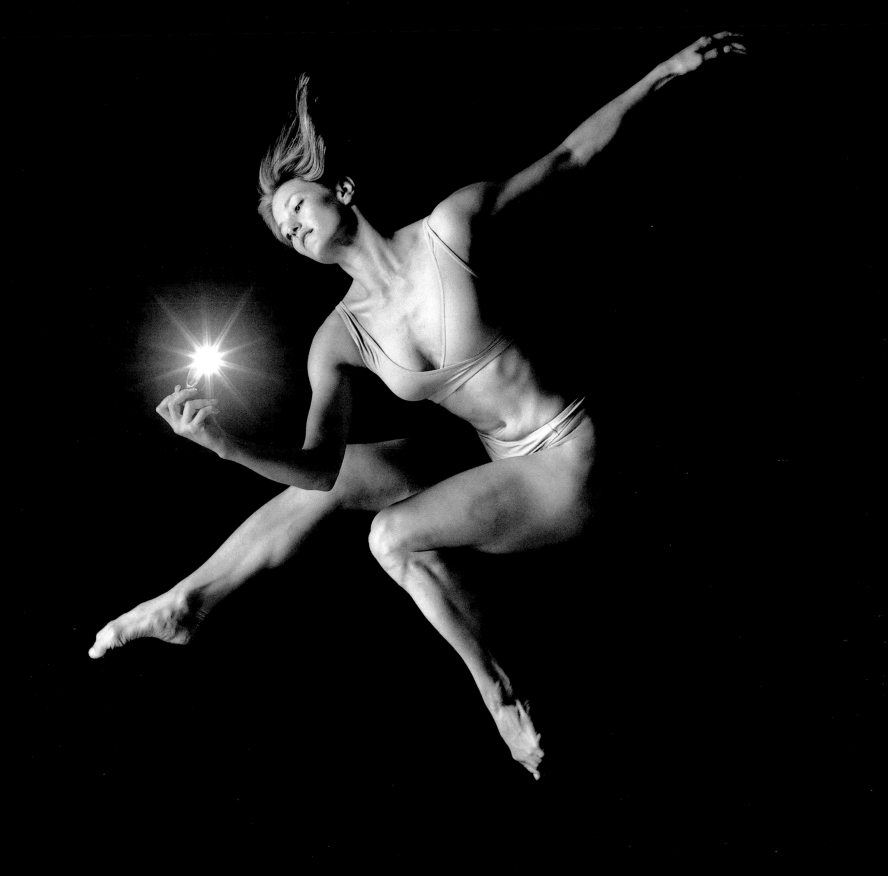

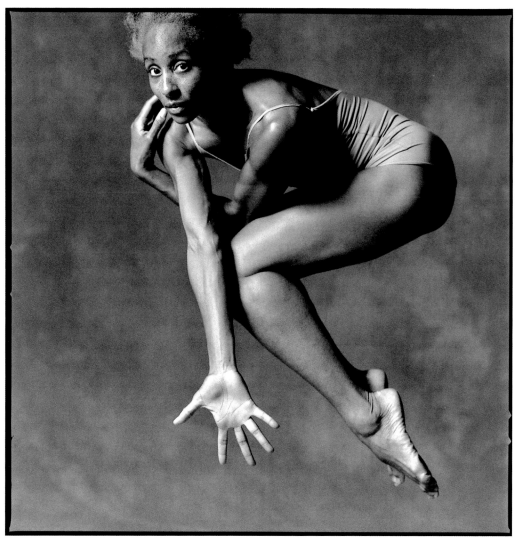

46

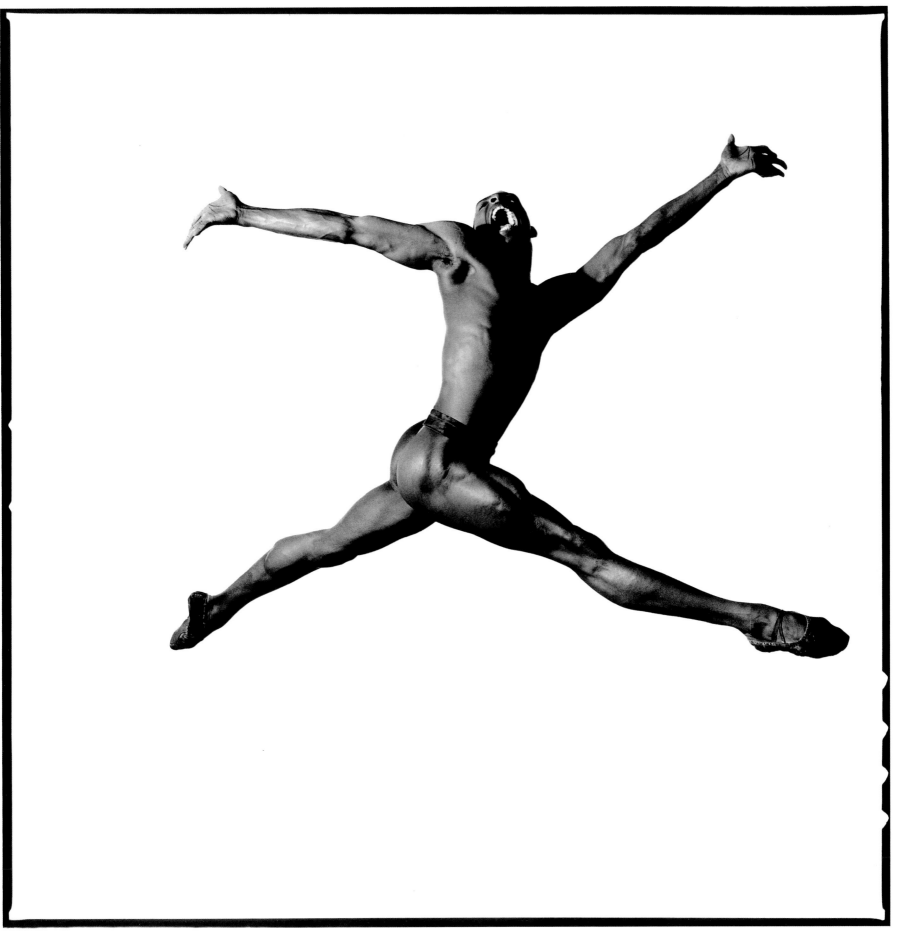

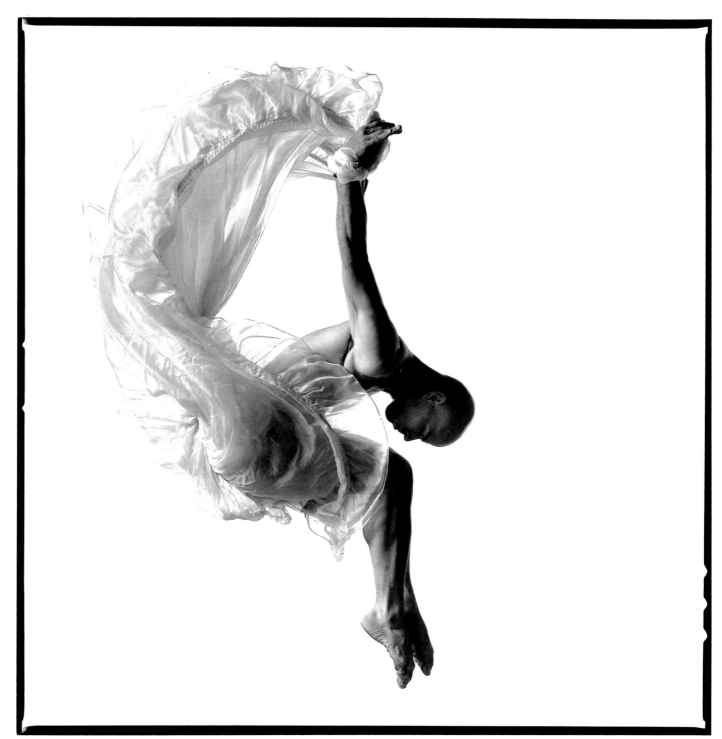

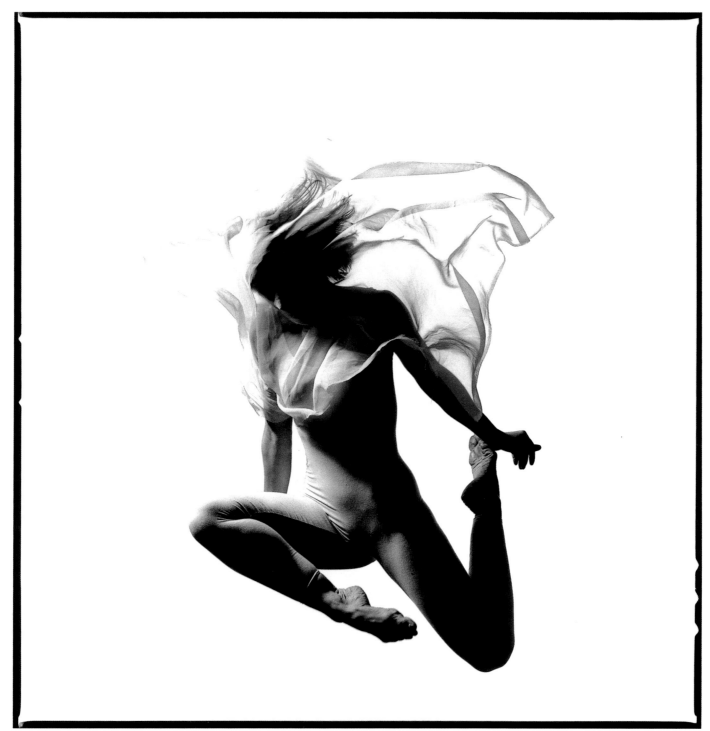

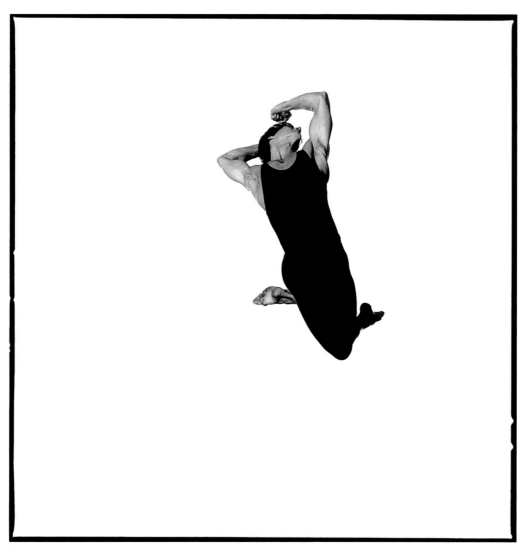

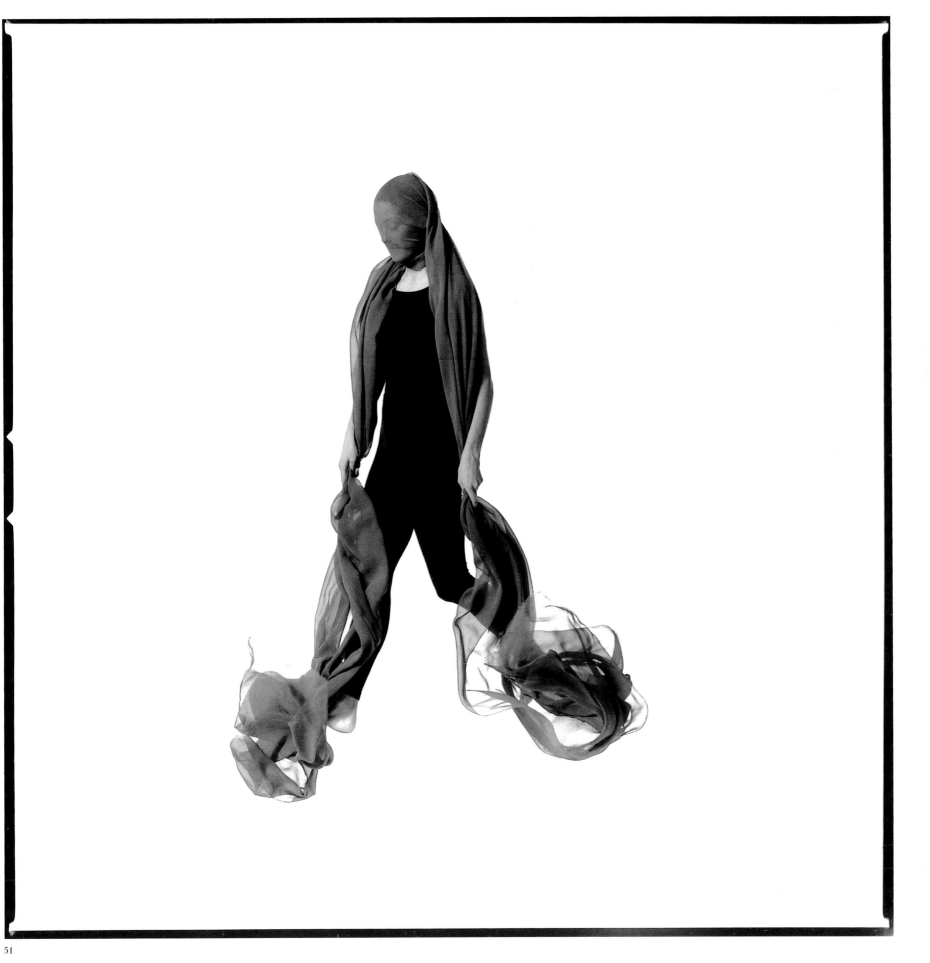

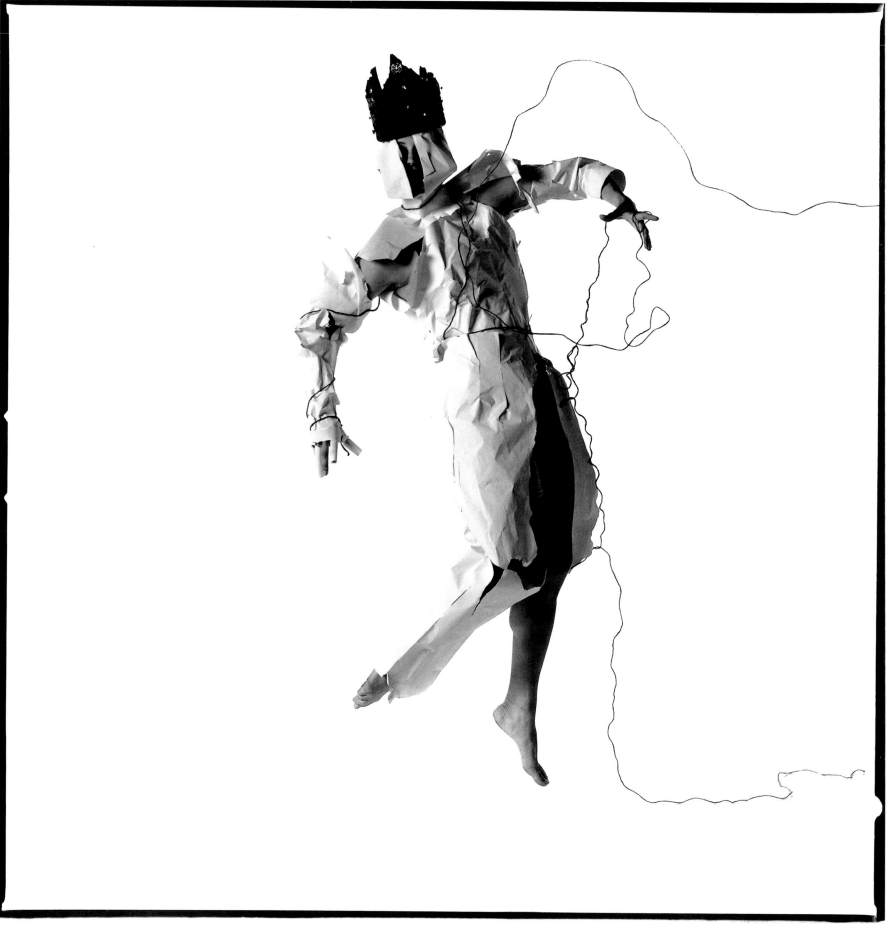

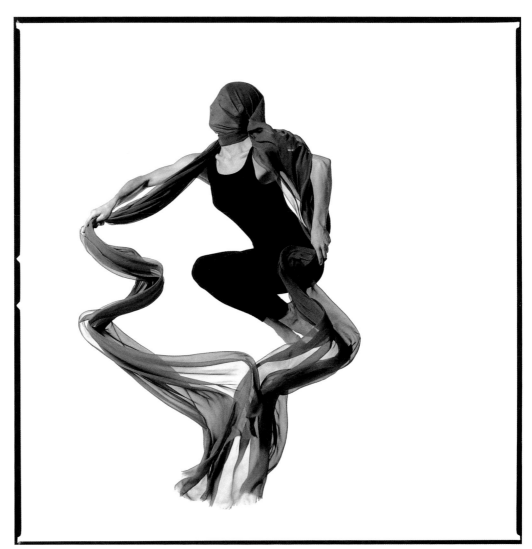

53

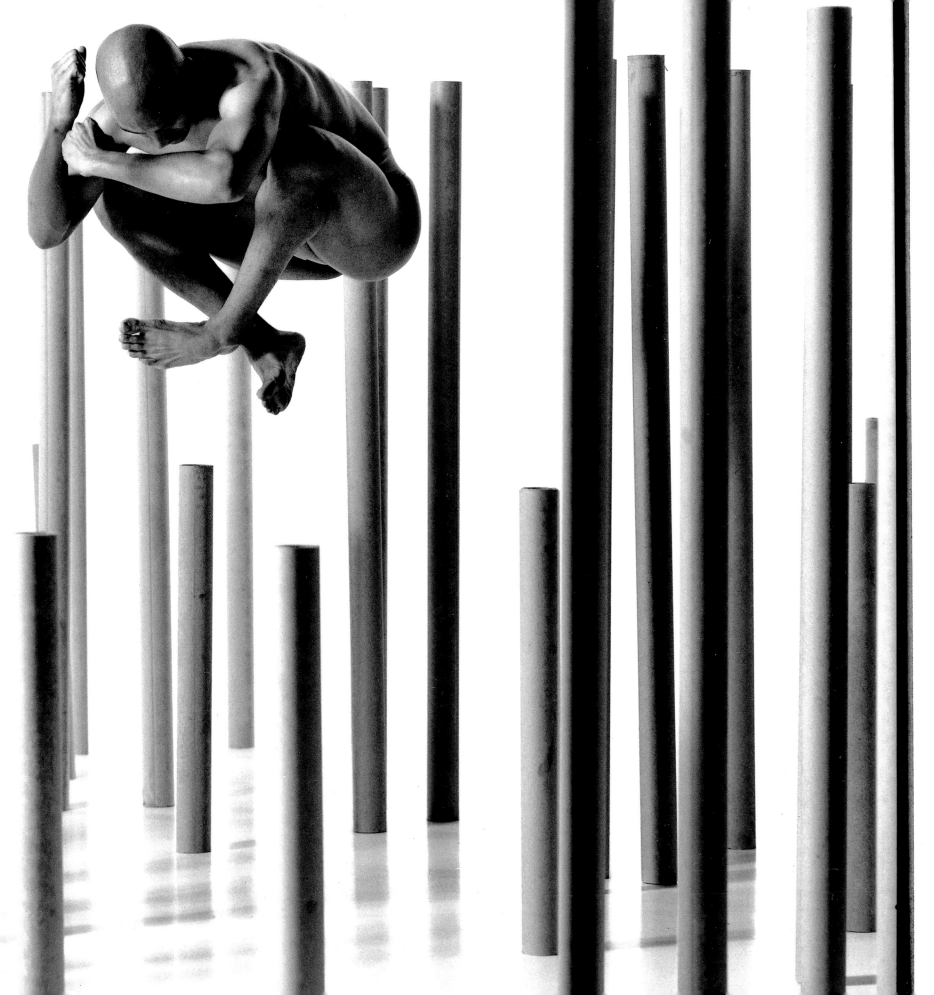

31 Adam Battelstein, Jude Woodcock
PILOBOLUS 1992
Jude and Adam had worked together as members of the Pilobolus dance
company for many years. I often explore with them the illusion of balance
and, in this case, repose. An unexpected dividend of this photo was Jude's
reflection in the polished floor. These positions are often excruciating for
the dancers, especially when taken out of the flow of their movement.

32 Sheila Buttermore, Teal Marx
Symbiosis **ON DANCE NETWORK 1992**

33 Andrea Weber, Robert Weber 1996
I've worked with Andrea and her brother Robert
since I photographed him in 1990 as part of a workshop I was
giving in Aspen, Colorado. They were actually the first gymnasts
with whom I had ever worked, and luckily for me they were
also dancers. Robert and Andrea communicate with one
another without speaking. After working with me a lot
over the years, Andrea can also intuit what I want
without my giving her direction.

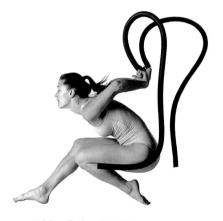

Ashley Roland 1995

34 Jack Gallagher, Linda Sastradipradja 1992
I first met Jack when he was dancing in ISO with Ashley Roland
and Daniel Ezralow. I was asked to give a workshop in 1992 for the
International Center of Photography in connection with my 'Breaking
Bounds' exhibit, and I decided to use that as an opportunity to work with
Jack and Linda. We weren't trying to create preconceived imagery, but
because someone once called this photograph 'Adam and Eve',
that is what it has signified for me ever since.

35 Adam Battelstein, Kent Lindemer, John Mario Sevilla,
Sebastian Smeureanu *Ocellus* **(Choreographers: Lee Harris,**
Moses Pendleton, Jonathan Wolken, Robby Barnett)
PILOBOLUS 1992

36 Hope Clark, Matthew Stromberg,
Albert Elmore Jr., Lisa Dalton
STREB/RINGSIDE 1996
Elizabeth Streb's choreography relies on
daring physicality. In this group shot the dancers
are doing a trademark Ringside move called 'around
the world', in which they spring off the floor, do a 360-degree
flip and land on their stomachs, making a perfect circle with
their bodies. Normally, the dancers perform this maneuver
from different angles, but I wanted to stack them up so they
would become a many-legged creature. Elizabeth is not
concerned with disguising gravity. In performance
her dancers land with groans and a thud, amplified
by mikes for the benefit of the audience.
At least I gave them a mat to land on!

37 Company members *Ocellus* **(Choreographers:**
Lee Harris, Moses Pendleton, Jonathan Wolken,
Robby Barnett) PILOBOLUS 1992

38 Andrea Weber, Chris Harrison, Andrew Pacho,
Harrison Beal For Raymond Weil Watches
ANTIGRAVITY DANCE COMPANY NYC
and Andrea Weber 1993
It was Andrea who introduced me to the Antigravity
company. Together we executed this pinwheel shot for
the Raymond Weil watch campaign.

39 Flipper Hope, Jack Gallagher,
Daniel Ezralow, Ashley Roland
For Raymond Weil Watches 1993
This shot, also for Raymond Weil, is one of a genre we call 'explosion
shots' which I developed with Daniel, Ashley and the ISO Dance Company.
Danny had brought unbridled energy and his crazy spirit to our many photo
sessions throughout the years. Ashley's gymnastic background helped her
jump off her supporting arm. This shot is basically a chaotic situation
which miraculously coheres at one particular split second.

40 Muriel Maffre, Ashley Wheater, Jais Zinoun
Aurora Polaris (Choreographer: Helgi Tomasson)
SAN FRANCISCO BALLET 1993

41 Company members *Ludwig Gambits*
BALLET TECH (Director: Eliot Feld) 1995
This is one way to fit 16 company members on
my 25-foot cyclorama.

42 Darren Gibson and Company *Evoe*
BALLET TECH (Director: Eliot Feld) 1991

43 Ashley Roland 1991
By transforming the ordinary, Ashley can bring
a new twist to just about any situation.

44 Desmond Richardson COMPLEXIONS 1995
Desmond was a lead dancer with Alvin Ailey and now has his own
company, Complexions. During this improvisation session we wanted
to capture the simple beauty of his form.

45 Ashley Roland 1997
During this most recent session with Ashley,
we gave her an instant camera so that she could
take a picture of me. To our surprise, we could
barely see her camera, just its flash.

46 Kathy Thompson 1996
This was from my second session with Kathy, who was working in
Switzerland at the time. While she was on tour in the States, she spent a day
in New York so that we could work together. Kathy is a wild woman who
does amazing, non-repeatable movements. In the contact sheets I was
struck by how long her arms and legs looked.

47 Darren Gibson *Evoe*
BALLET TECH (Director: Eliot Feld) 1991

48 Arthur Aviles 1993
Arthur came to the session with a costume he performs in, but instead of wearing it he tied it to his
wrists. It ended up looking like a parachute, an angel's wings, or, in this case, a crescent moon.

49 Gail Gilbert *Cirrus* 1993
Gail has choreographed a series of dances with
diaphanous fabric, called *Cirrocumulus Ungulates*, in
which she explores the representational and metaphorical
potential of the fabric. Cirrus are clouds that do not lead to
rain but often indicate the location of a distant storm. Gail
likes to think that the scarf is an extension of her skin
and that it makes her jump look more like a cloud.

50 Joseph Mooridian
HUBBARD STREET DANCE CHICAGO 1994
Every year Hubbard Street advertises its season in Chicago by
hanging two very narrow vertical banners side by side along
Michigan Avenue. We are therefore always looking for ways
to photograph the dancers as 'narrowly' as possible.

51 Ashley Roland 1995
When I work with commercial clients,
they usually look at works I've done for myself and ask
me to build on the concepts or imagery for an advertising
campaign. In this case it was the other way round. I had
photographed a campaign in colour for Sydkraft, a Swedish
energy company, where I illustrated their concept of not
seeing the wood for the trees by wrapping Ashley in green
silk and tying the scarf Magritte-like over her face. Ashley
and I saw rich potential in this idea so she came back
another day to fool around with the leftover prop
which we shredded into strips.

52 Ashley Roland *Motorella*
(Choreographer: Ashley Roland) 1994
This is my only photograph of Ashley that actually
comes from a choreographed dance. *Motorella* is about
a modern-day Cinderella. It is set in Detroit, Michigan.

53 Ashley Roland 1995

54 Sham Mosher 1997
I always like to work with earthy props when I photograph Sham. I wanted him to be in
a pile of sticks. Sham suggested we get some cardboard cores used for rolls of fabric, so we
borrowed some from a wholesaler across the street. We cut the cores into different sizes to
create depth and perspective on the set. I had intended the picture to look like a forest,
but it came out looking more like a musical instrument.

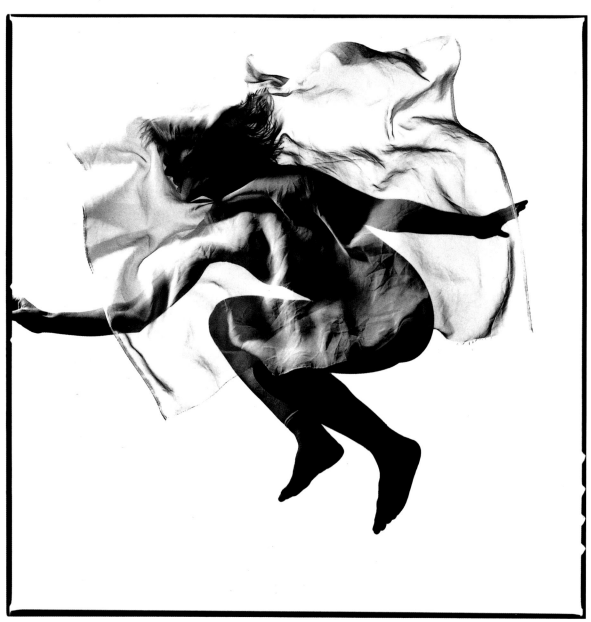

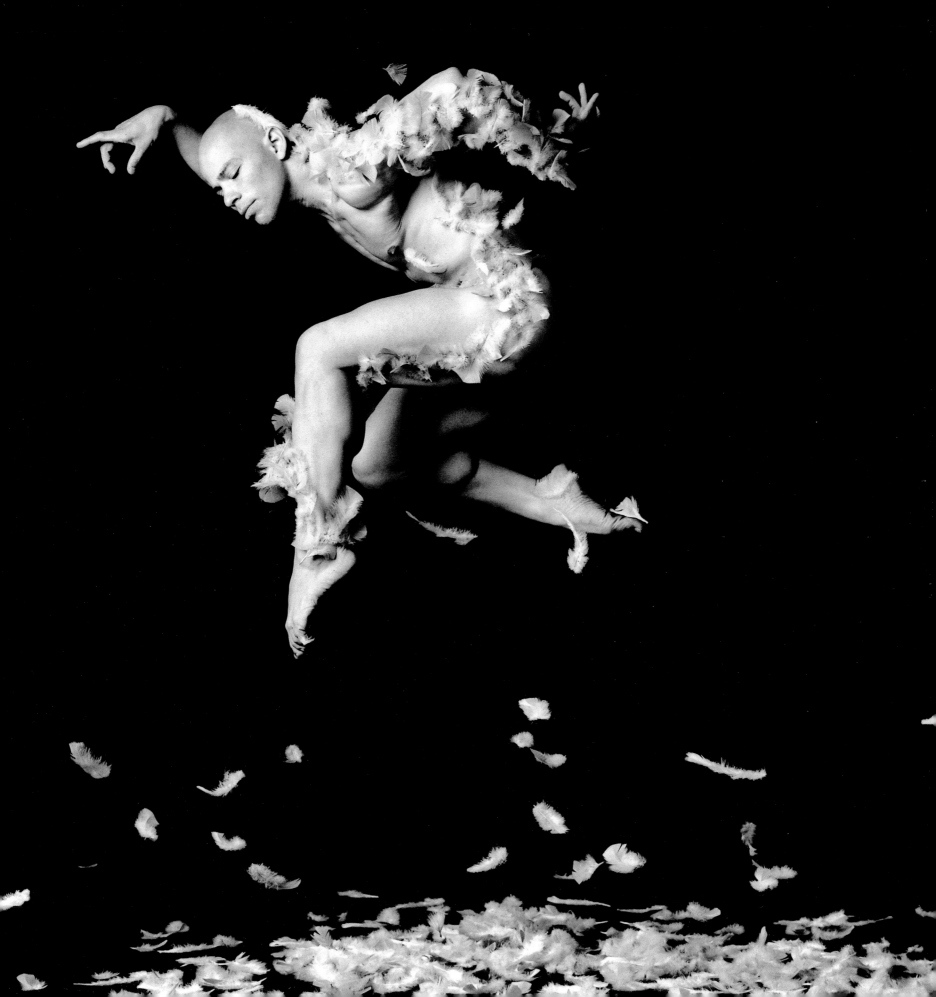

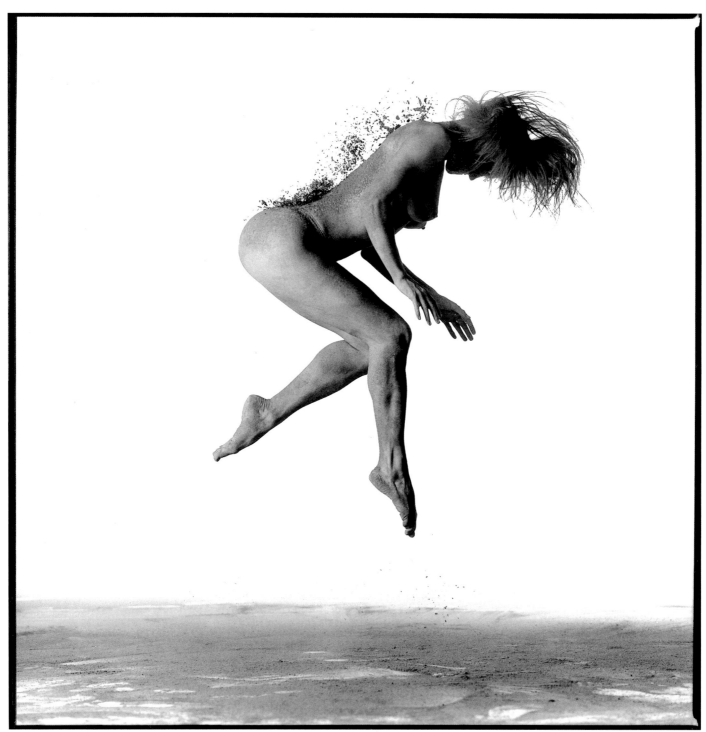

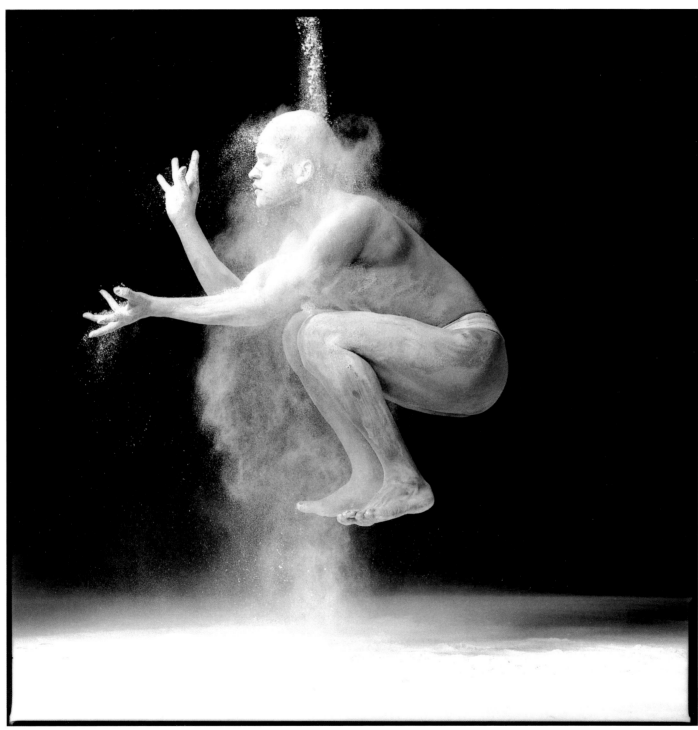

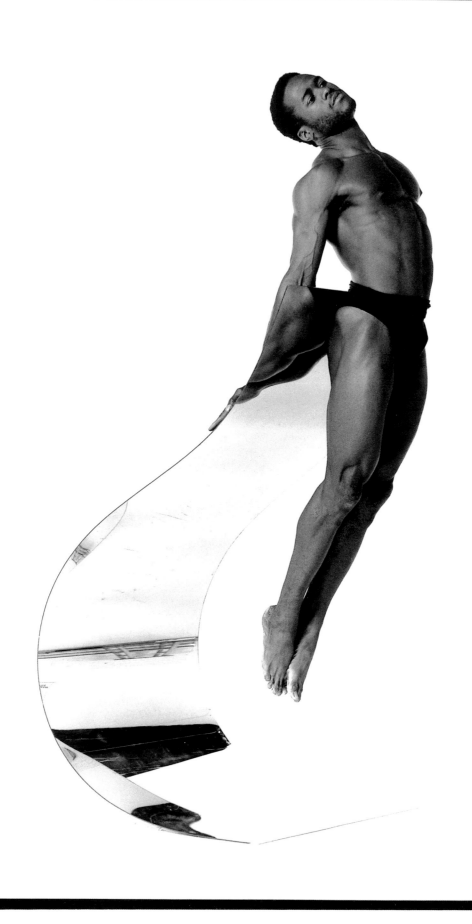

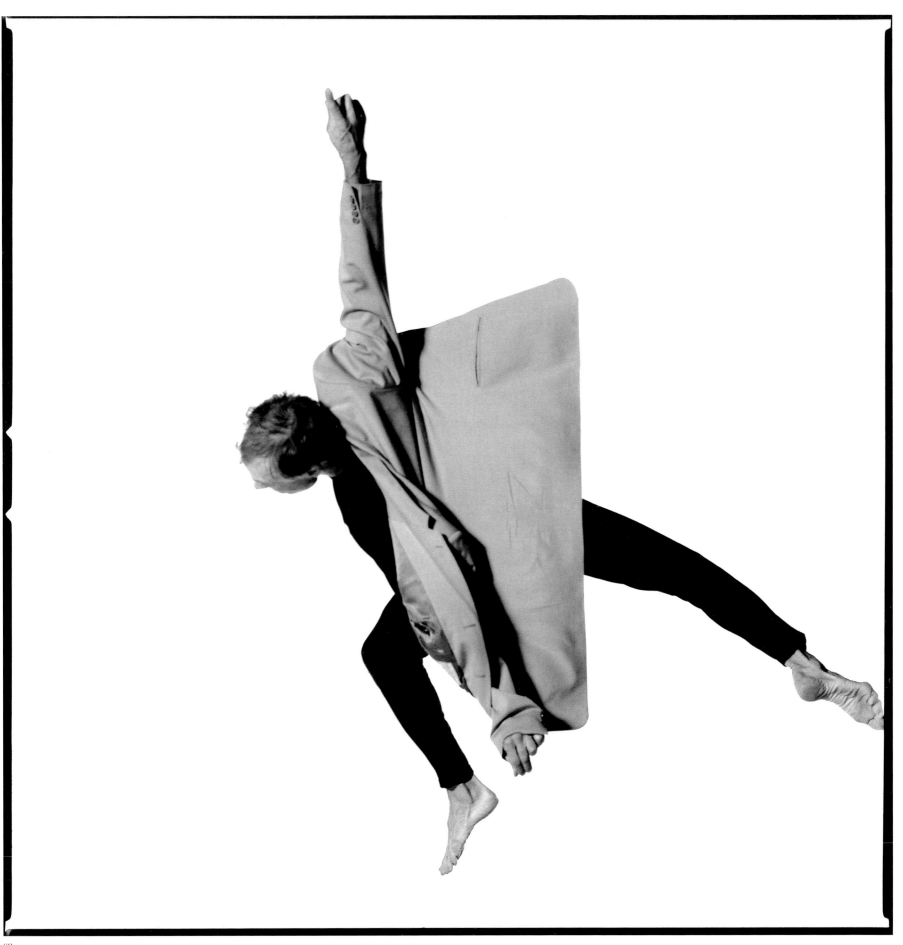

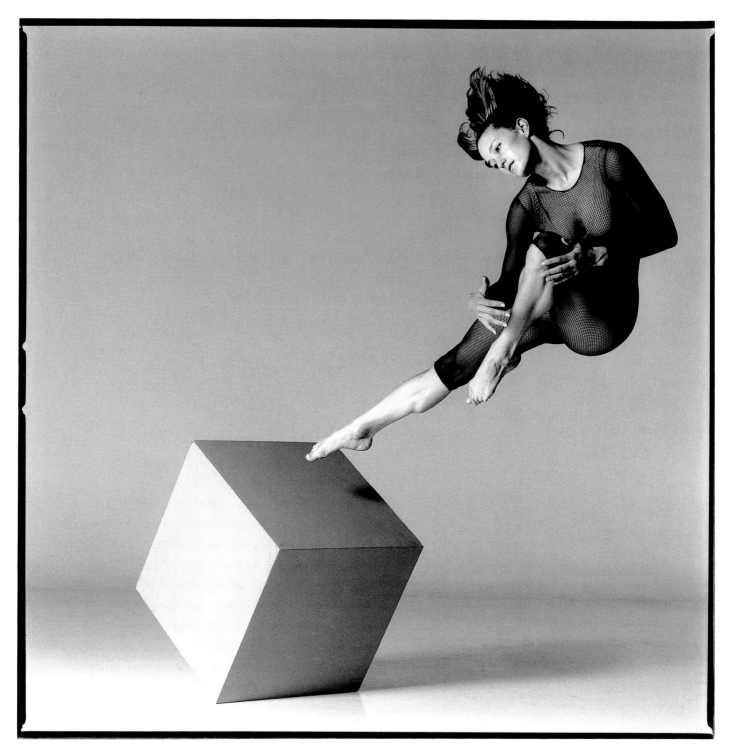

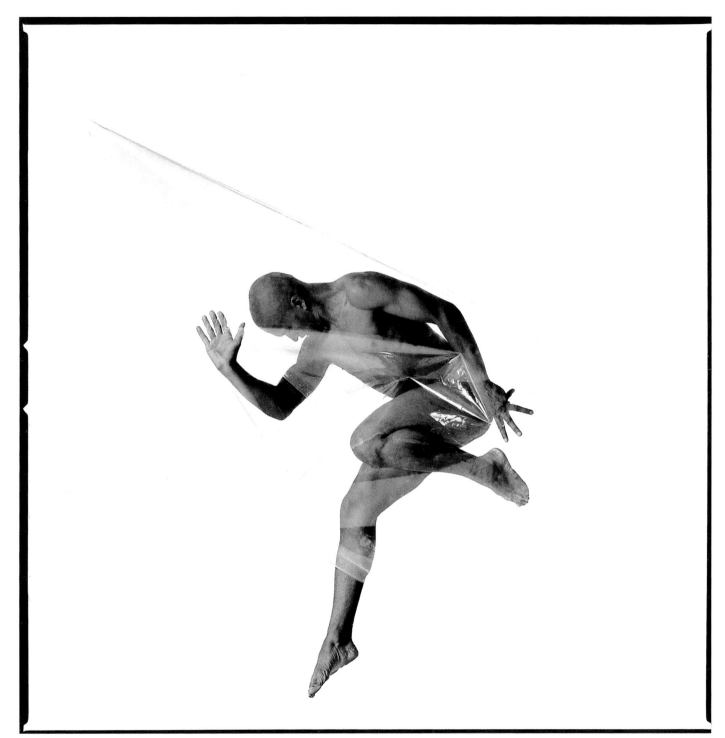

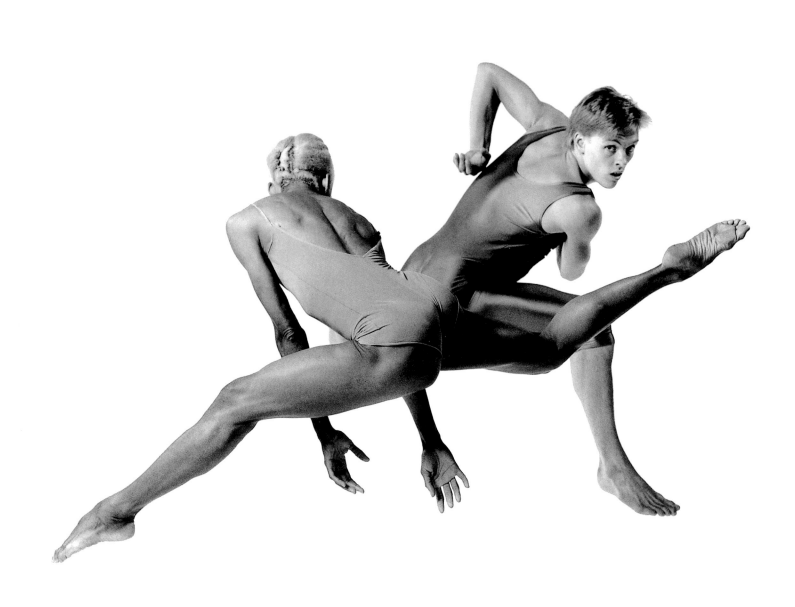

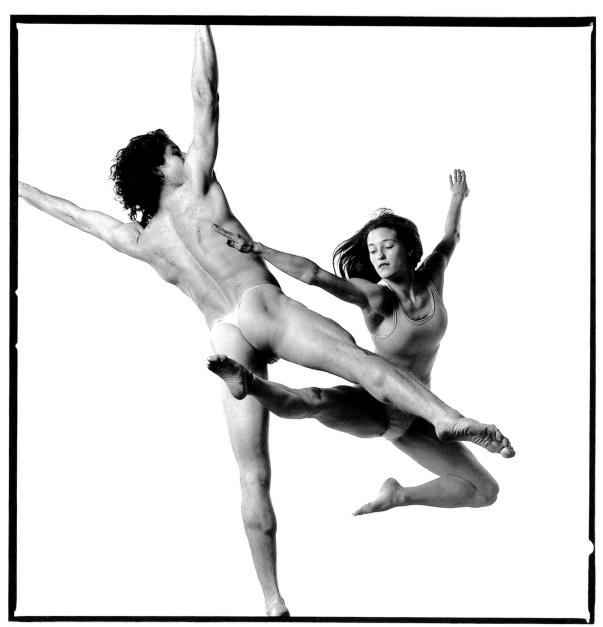

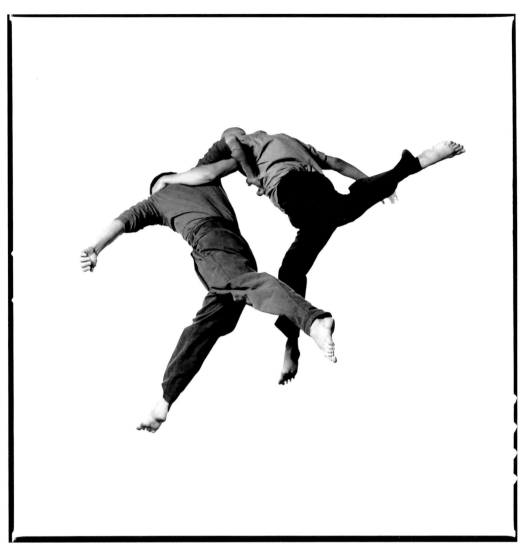

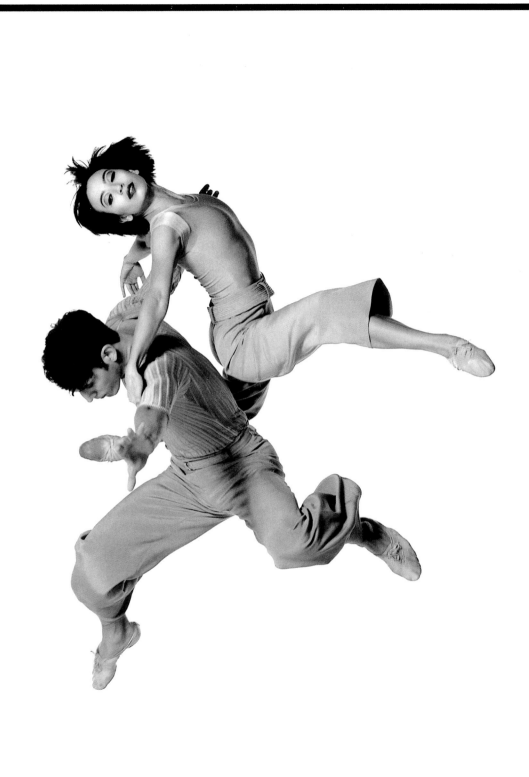

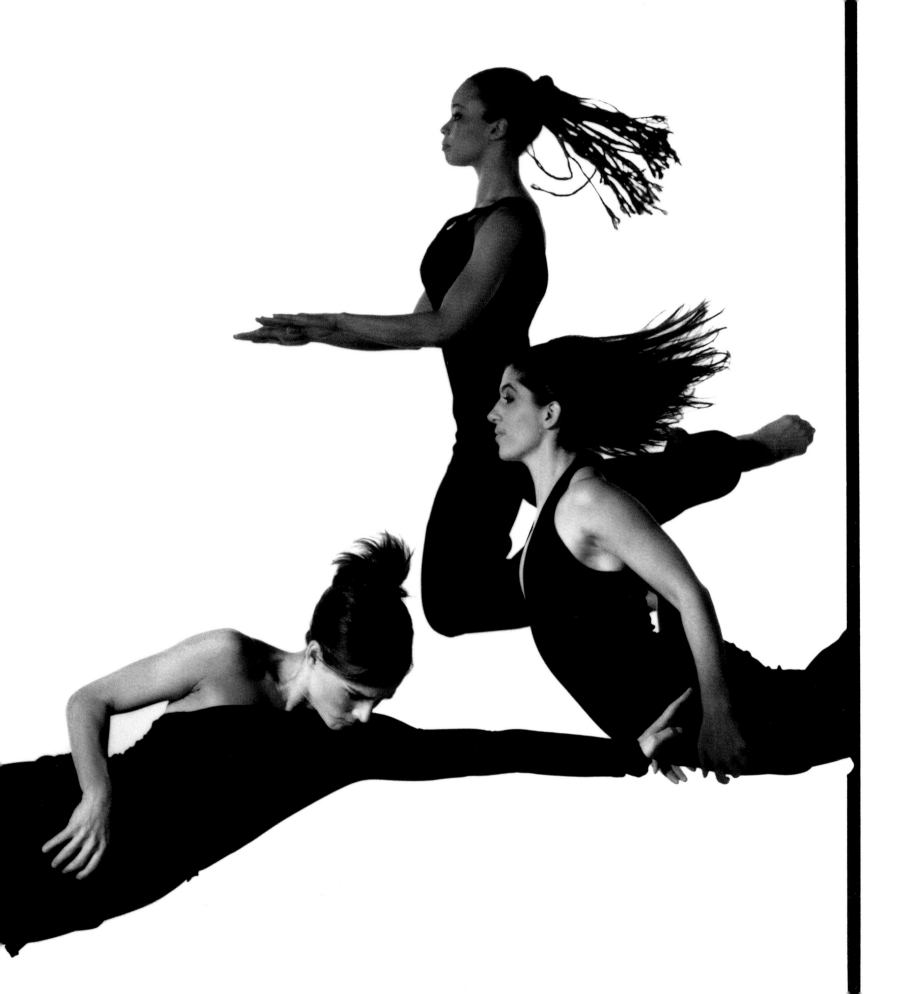

55 Gail Gilbert 1993

For this photograph, Broncolor (who manufacture my strobes) suggested we try their Satellite Reflector. We wanted to throw Gail into silhouette and have the scarf be like a layer of skin. To me, she seems to be turning into an animal before our eyes.

56 Arthur Aviles 1996

I wanted Arthur to look like a mythological birdman, so we not only glued feathers on him but tossed them in the air as well. Arthur said that the photo session inspired him to create a dance called *Now I Know Why That Caged Bird Sang*.

57 Ashley Roland 1995

This is another in the cocoa series. We sprinkled Ashley's back with cocoa before every jump and I timed the shot to when the cocoa flew up.

58 Sham Mosher 1995

We used the same mixture of flour and sugar as in plate 9. We found one jump that worked and Sham repeated it many times, the variable being the rate and amount of flour falling on him. We wanted him to look as though he himself was being poured and had coalesced into that shape. In the photo he looks weightless, but every time he landed he let out a big grunt.

59 Flipper Hope 1994

Ashley Roland 1995

60 Didier Silhol 1995

This photo was taken in Paris during the filming of a documentary on my work by Sylvie Fleurot. Didier is doing a kind of barrel roll which is usually hard to photograph because the arms and legs get foreshortened. We had to make sure his limbs stayed as parallel to the camera as possible.

61 Ashley Roland 1997

I love to make it seem as though an invisible force has blown the dancers and the props apart.

62 Sham Mosher 1997

We wrapped Sham in a piece of clear plastic which we shaped into a cone. I wanted him to look as if he was contained by, and at the same time emanating from, a ray of light.

**63 Kathy Thompson, Gerald Durand
LES NOMADES 1995**

I photographed this in Vevey, Switzerland, where I was giving a workshop for Broncolor.

64 Daniel Ezralow, Ashley Roland 1988

Ashley and Danny were trying to see how close they could get to one another in full flight without colliding.

**65 Demetrius Klein, Patrick Ryel
La Valse DEMETRIUS KLEIN DANCE COMPANY 1992**

**66 David Gomez, Jennita Russo
HUBBARD STREET DANCE CHICAGO 1995**

One of the strengths of this company is their creative ability to improvise.

**67 Mia McSwain, Gail Gilbert, Patricia Ann Kenny
THE PARSONS DANCE COMPANY 1996**

This was originally shot in colour (and converted to black and white) for the Women's Fashion Supplement of the *New York Times* Sunday Magazine. Usually I don't fuss with hair and make-up when I shoot, and I like to keep clothing as simple as possible, but in this case the hair extension added movement to the shot, and Gail's hair was gelled in that position – something I had never done before. What I really love, besides the floating quality, is Patricia's strong horizontal.

68 Ashley Roland, Flipper Hope 1994
Ashley and Flipper were trying to see whether they could make
it seem as though they were both entwined and flying.

69 Jack Gallagher, Linda Sastradipradja 1992
I wanted Linda to look as if she were literally Jack's shadow up in the air, so
we made sure no light fell on her. She is much smaller than he is but we still
had to put her way back to make her look even tinier and further away.

75 Flipper Hope, Andreas Bjorneboe,
Stephen Choiniere 1997
This was part of a series of photos I created for Tipness Health
Clubs in Japan. To my client's amazement we produced ten
different configurations in one day. Of course, working with a
longtime collaborator such as Flipper, whose energy
galvanizes everyone in the room, made the task easier. And
new faces such as Stephen brought unexpected twists.

70 Dave Parsons, Gail Gilbert
***Bachiana* THE PARSONS DANCE COMPANY 1994**
Dave says this is a signature move from what he calls his 'new
Classicism'. When I first photographed Dave in 1982, he was still a
member of the Paul Taylor Dance Company and had yet to develop his
own choreographic style. In those days he used to just throw himself
around in the studio and we'd get wild and crazy results. Now, when
Dave comes in, even just to play, I get the feeling that he has thought
long and hard about the shapes he is making with his body. He has a
whole movement vocabulary for himself and his dancers.

76 Nadine Mose, David Brown,
Emmanuele Phuon, Christian Canciani
Based on *Mandeville . . . La Vie Continue*
ELISA MONTE DANCE 1994
Different moments of the dance were fused into one frame,
in the hope of conveying the work's overall feeling.

71 Robin Branch, Leajato Amara Robinson 1996

72 Andrew Pacho, Kim Anthony Hamilton
ANTIGRAVITY DANCE COMPANY NYC 1992
Pacho (and Chris Harrison of Antigravity) are so full
of creative ideas that I sometimes have to put my foot
down and say: 'No new ideas!' They are also ingenious
at figuring out how to do, or how to coax others to do,
the impossible things I often ask of them.

77 Rika Okamoto, Kathy Buccellato, Camille M. Brown 1996

73 Rika Okamoto, Kathy Buccellato, Camille M. Brown 1996
These three young women, who were then with the Martha Graham
Company, came in for an improvisational shoot after I had
photographed them for the company.

78 Eli McAfee, Albert Elmore Jr., Hope Clark,
Matthew Stromberg, Lisa Dalton
STREB/RINGSIDE 1996
Elizabeth Streb has eliminated a perspective based on vertical
bodies. Although the dancers look as though they are coming
forward, they are not. They are jumping up and making a 'table',
another signature Ringside move. I caught them on the way up,
before their bodies form a horizontal plane and before,
ultimately, they land on their stomachs.

74 Hope Clark, Albert Elmore Jr., Matthew Stromberg
STREB/RINGSIDE 1996
I didn't cut off Matthew's head on purpose in this
shot. We just put together different moves that we liked
from various Polaroids we had taken. Matthew has told me
that in performance one rises above the fear of the physical
danger involved and is carried through by the progression
of the choreography. In the studio, where each move is
taken out of context, the dancer has to psych him or
herself up for each individual manoeuvre.

79 Ned Maluf, Christopher Batenhorst, Paula Gifford *Wall/Line*
STREB/RINGSIDE 1994
The dancers are running sequentially headlong into the wall. The first person is
held up by the pressure of the second body. The third guy has to grab the top of the
wall across the width of the two bodies. The moment I shot is when the outside
man, Ned, just lets go from the wall.

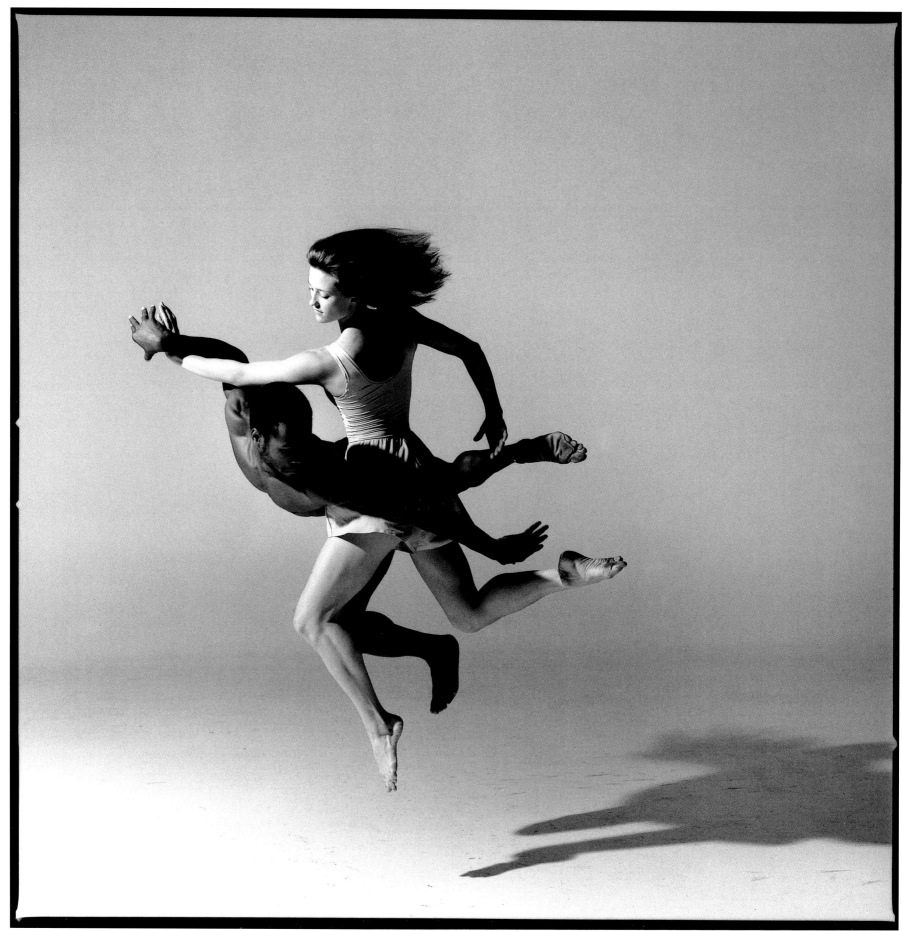

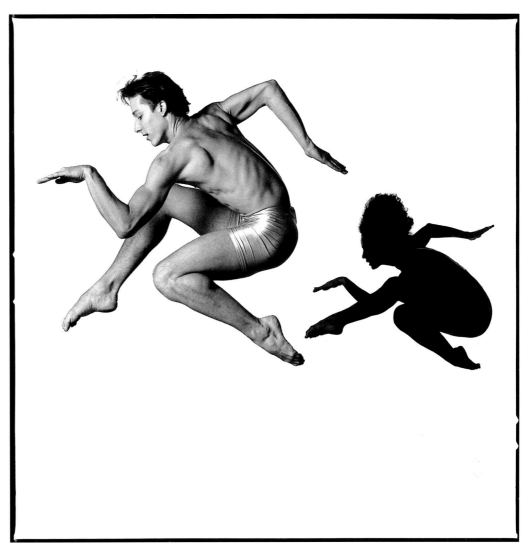

69

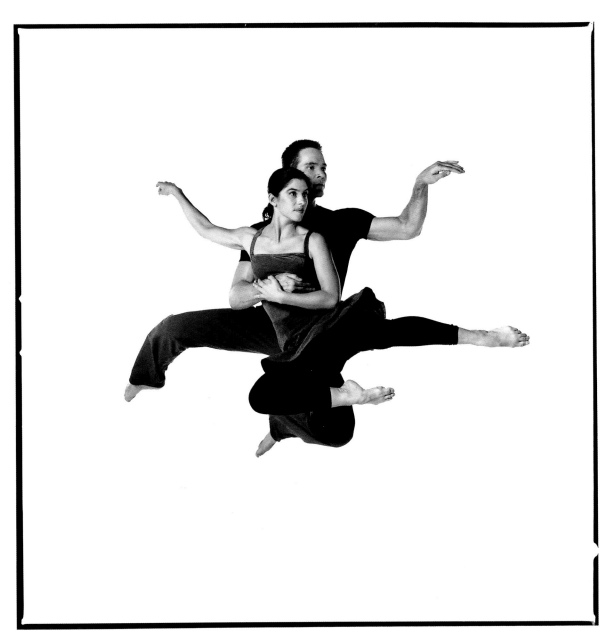

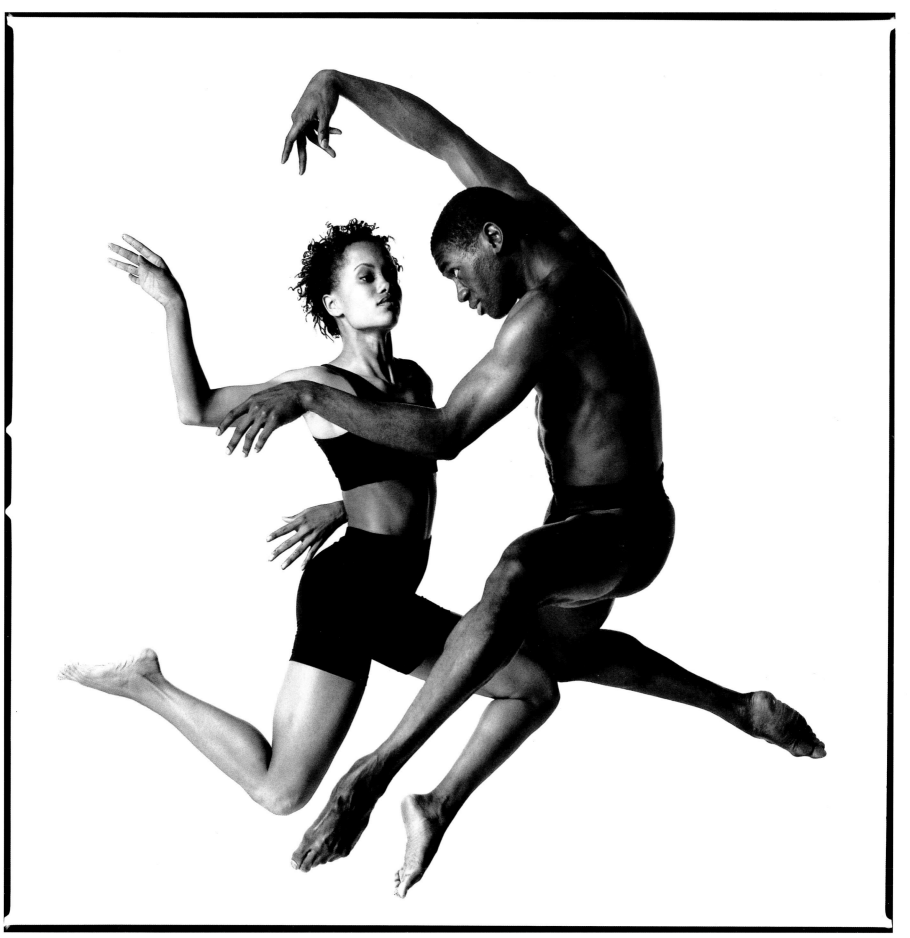

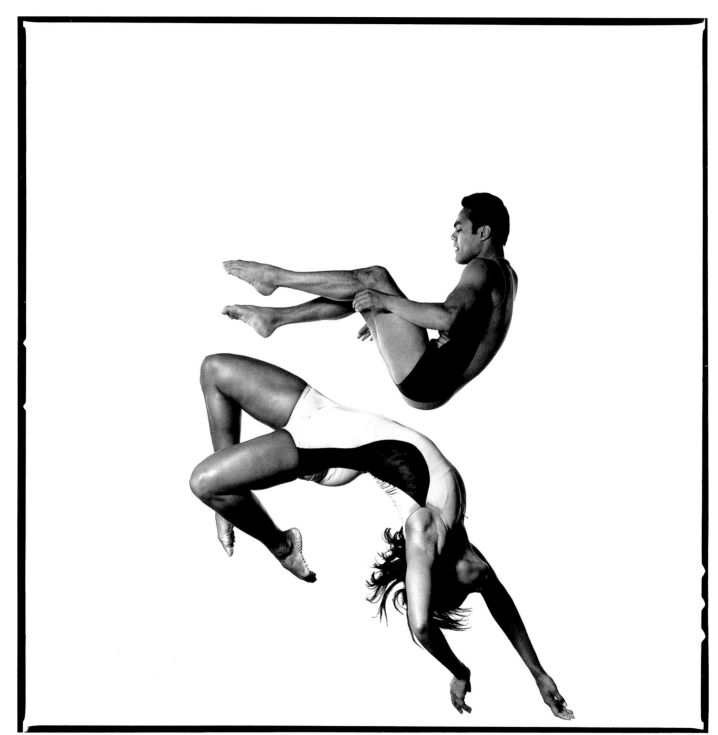

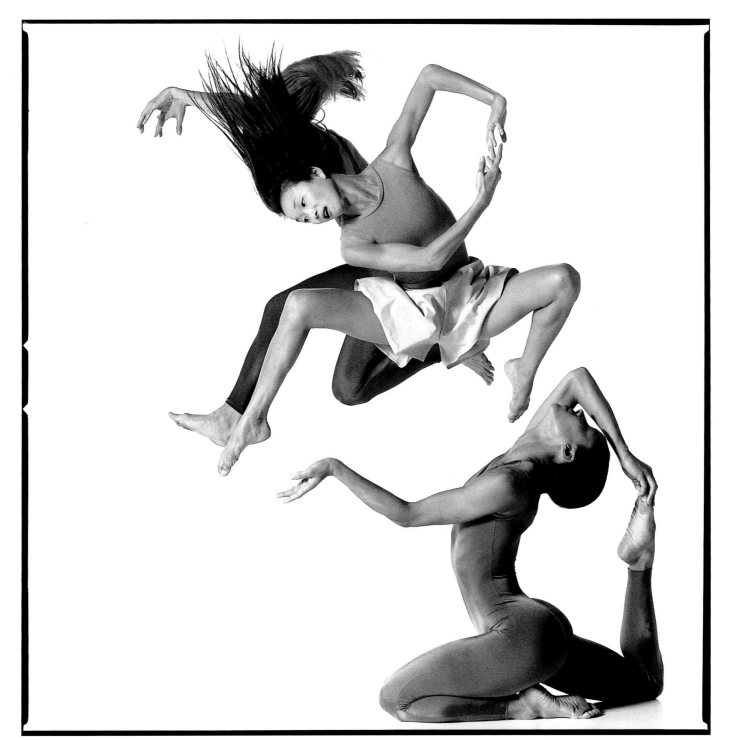

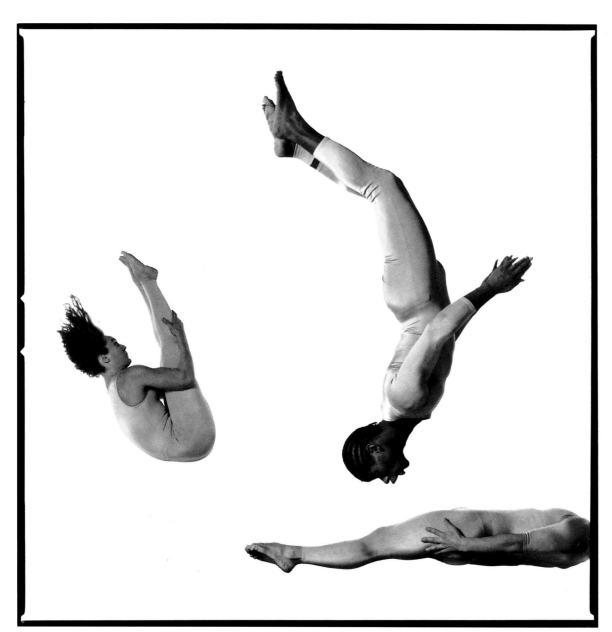

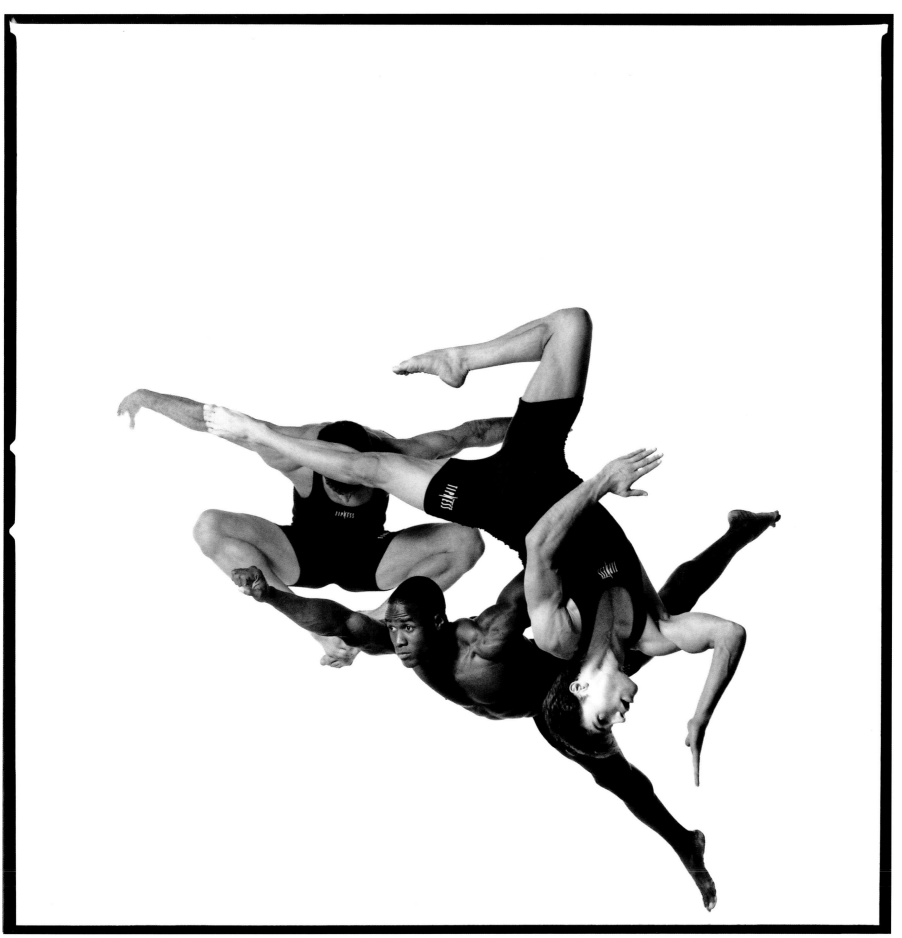

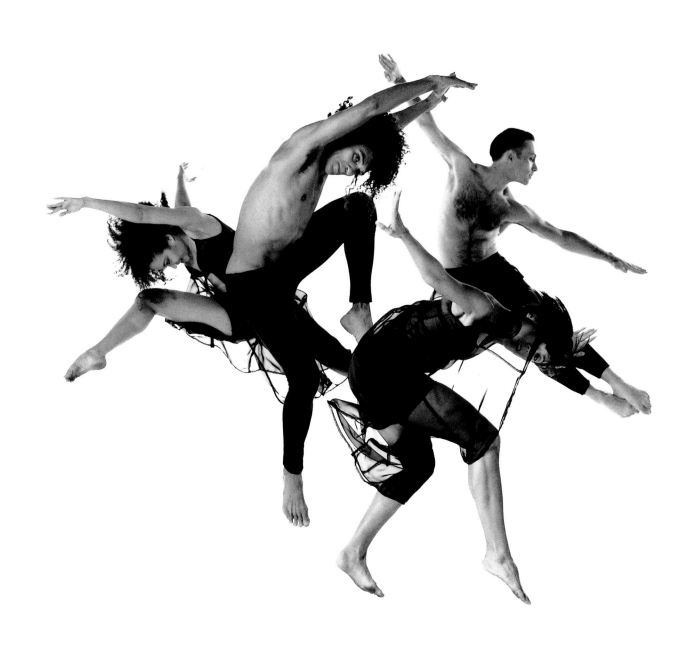

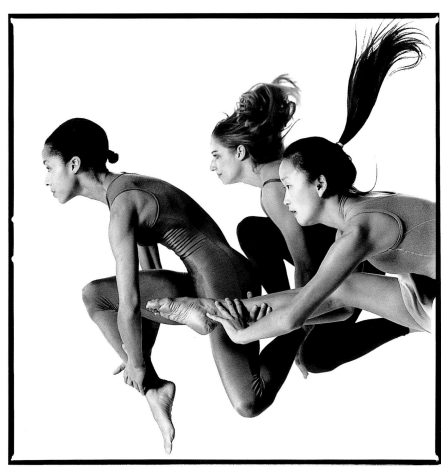

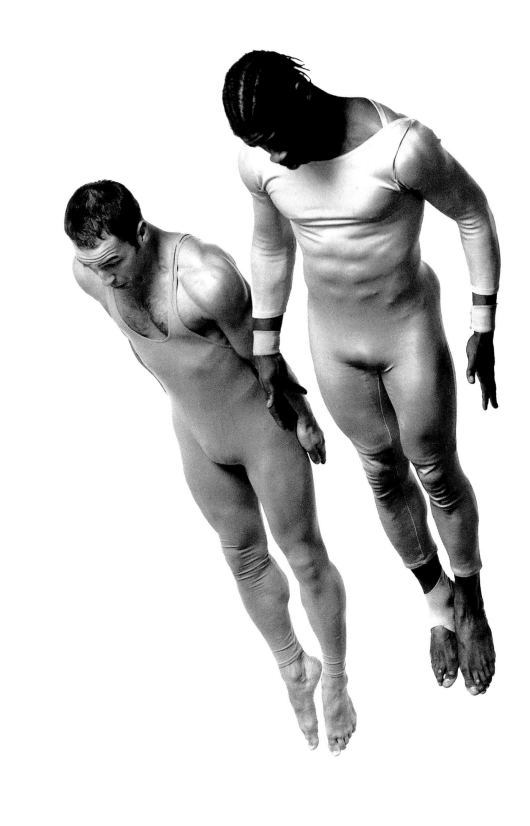

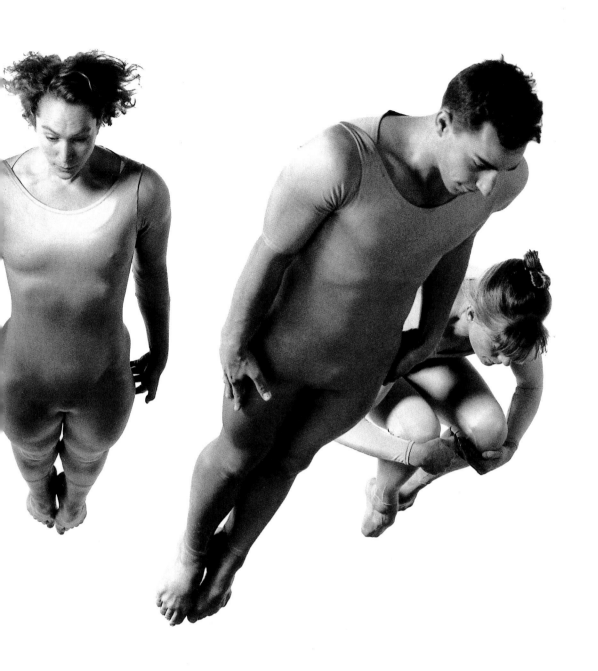

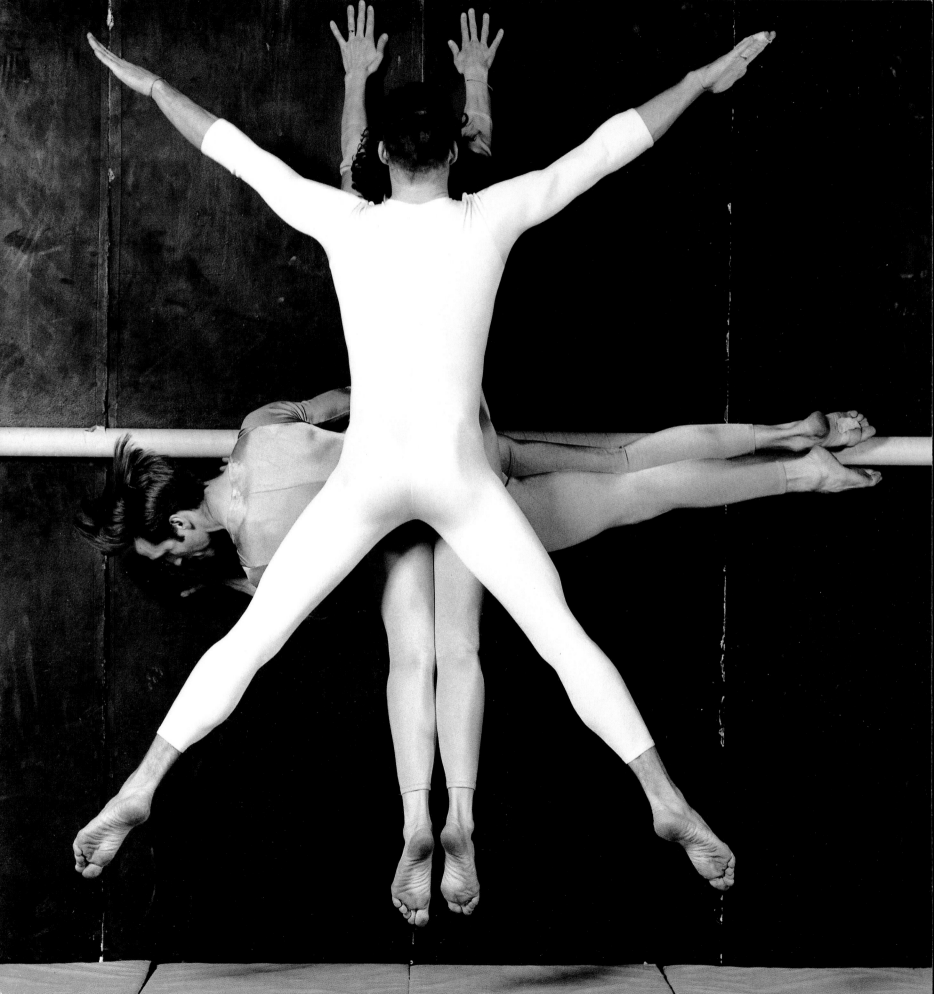

LOIS GREENFIELD'S PHOTOCHOREOGRAPHY

Lois Greenfield is the most innovative and prolific photographer of contemporary dance. Her style is widely copied, though her imitators, lacking her acuity, inevitably fall short of the mark. She is rightly admired for her original achievements in a field which, in spite of continual technical advances, still presents formidable challenges. If her earliest work was characterized by some uncertainty, as she struggled to come to terms with the central paradox of dance photography – how, in a still image, to make the dance *move* – she can today take pride in an oeuvre of remarkable quality, consistency and depth. This is due in no small measure to her understanding of modern and post-modern dance principles, absorbed over twenty years, as well as to her total mastery of her own medium: photography. This dual facility sets her apart from the mass of her competitors who are proficient in photography but remain relatively unschooled in the nuances of choreography.

By definition ephemeral, dance is an art which accommodates itself with great difficulty to photography. While it is always possible to make striking imagery of dancers in motion (magnificent leaps with outstretched limbs are inherently photogenic), the overall design – that is to say, the choreography – is all too often overlooked or, worse, misrepresented. A human body in dance is not simply an object positioned in space, but an object in flux, moving from one place to another according to a specific plan. Relations between dance and photography are therefore necessarily problematic, because the dancer's movements, charged with this larger meaning (the choreography), must nonetheless be distilled into a single image (or a few such images) at the expense of the whole. On the other hand, this process of distillation can also be the source of inspired imagemaking, as Greenfield's work makes clear.

Photography, the invention of which was announced to the world in 1839 after years of experimentation led by Niépce, Daguerre and Talbot, was the fruit not only of that research but also of inventions, theories and discoveries dating back to the Renaissance. In this sense photography was a belated offspring of Renaissance culture, adopting its *camera obscura* and adhering to its perspectival system and classic single point of view. Photography's initial impulse, understandably, was to *arrest* time, to *freeze* the image in the mirror (in its early days photography was often described as the mirror of nature), *not* to create images in which the subject seemed to be in motion. Movement would only begin to interest photographers several decades later, when mirror-like fidelity had lost its power to enthrall. In any case, it was impossible in photography's early years even to *show* a moving object or person with any clarity whatsoever. For instance, the only people seen on city streets in the first photographs just happened to be standing stock still long enough to have their presence registered, and even that presence is ill-defined, ghostlike. Even studio portraits of *sitting* people required head and arm rests to keep the body sufficiently still during long exposures. Only when photographic imagery had become a matter of routine did the public manifest its frustration with stillness, and

only then did photographers begin their quest for an image which would convey a convincing *sense*, or illusion, of movement.

Throughout most of the nineteenth century, therefore, the photography of dance was simply inconceivable. The romantic ballet was fully mature and enjoying its golden age before the words 'photography' and 'photographer' were even invented. A decade after Daguerre and Talbot had published their methods of permanently fixing a photographic image, photographers were unable to produce a clear picture of a moving subject, let alone to represent anything as complex as the ballet. The most *daguerreotypie*, for example, could offer the dance world was the posed studio portrait, and even this was destined to remain a rare and expensive gift (for a wealthy patron, for example) since the daguerreotype was one-of-a-kind. Even when, in the 1850s, the tiny *cartes de visite* eventually made photographic imagery of ballet stars available to the masses, this imagery was still in the form of portraiture. If, very occasionally, a ballerina was photographed pretending to hold a position, the photographer's objective remained celebrity portraiture rather than the convincing balletic moment. The latter task was left to lithographs which, having originated as drawings, could give free rein to the imagination and thus portray the ethereal *spirit* of the ballet (for example, ballerinas were shown floating among the clouds). When, *very* rarely, a photographer strove for something more than a demure posed portrait, the long exposures required dancers to be held in the air with cables (the chicanery later erased – retouched out – on either the negatives or prints). But if, to our eyes, both the portraits and the more ambitious attempts to evoke the dance resulted in stiff imagery which parodies the ideals of grace and effortlessness which the dancers strove to portray on stage, it must be said that nineteenth-century viewers were more than content to have mirror-like representations of celebrated prima donnas whom they had otherwise only heard about. Perhaps the best that can be said today of all these early efforts is that they represent a kind of *proto* dance photography: since their subjects were always required to remain completely motionless, no trace of the controlled energies unleashed by the bodies in real dance could be registered.

This is not to say, however, that no advances concerning the photography of dance were made in the nineteenth century; it was simply that they were indirect contributions. The American Eadweard Muybridge and the Frenchman Jules-Etienne Marey devised photographic techniques for breaking down and analysing the mechanics of human and animal movement. Both men were fascinated by the limitations of the human eye, and were convinced that reality did not conform to human perceptions of it, perceptions which had been channelled by misleading artistic convention. Muybridge's method sampled split-seconds of movements and gestures and then presented the totality within a matrix of single images, while Marey chose a more synthetic approach – *chronophotographie* – which clearly rendered phases of the

movement or gesture on a single plate, an effective way in which to demonstrate the continuity and coherence of animal and human locomotion.

These were no ivory-tower musings: the principles Muybridge and Marey uncovered encouraged athletes to revamp their training methods, physicians to devise better means of repairing muscle and bone, and armies to develop better marching techniques. The modern science of ergonomics was born of this knowledge. The most sensational single finding of all was, of course, Muybridge's sequence of a horse at gallop, which had until then been represented erroneously in art, the human eye never having been able to grasp the fact that the four feet of the animal were off the ground at one time. The shock of discovering that this was indeed the case did much to publicize both Muybridge's and Marey's findings, and forced artists to take a second look at all the conventions relating to the depiction of humans and animals in motion. This would include painted, drawn and photographed renderings of the dance.

Expressive dance photography (such as we have today) has its roots in a *fin-de-siècle* international style and movement called Pictorialism. Pictorialists had artistic ambitions for photography, which had hitherto, in their eyes, worn the disreputable mantle of commerce. One strategy towards this end was to print photographs in ways that resembled as closely as possible the fine (that is, respectable) arts. Another tactic, albeit unconscious, was to photograph highbrow subjects. Thus the dance became a popular Pictorialist subject, whether in the form of classical ballet or in the form of avant-garde activity represented by Isadora Duncan, the Ballets Russes and Ruth St. Denis, among others. Now the focus was on the spirit of the dance rather than on its celebrated performers, and this goal demanded elegant and convincing illusions of movement.

There were substantial Pictorialist accomplishments in this regard. Thus, Arnold Genthe produced some magnificent photographs of Isadora Duncan and her pupils performing outdoors. He also made one rather sombre study of Anna Pavlova actually performing on stage, which is, to my mind, the first true dance photograph. But the fact remains that, with this exception, technical obstacles continued to prevent the development of a true dance photography – that is, *moments actually seized from the flux.*

Dance photography in this latter sense really begins in the 1930s, when the availability of fast films, light meters and electronic flash finally allowed imagemakers to freeze a given split-second of dance action while rendering the performers clearly. What is surprising is how few photographers chose to exercise these options. The portrait-style remained the norm throughout the 1930s and 1940s, practised by accomplished professional photographers like George Hoyningen-Huene, Edward Steichen, Horst P. Horst or James Abbe. Sometimes this portraiture was merely a convention (or a consequence of public demand, since fashion magazines like *Vogue* and *Vanity Fair* paid handsomely for such pictures); at other times it was a matter of

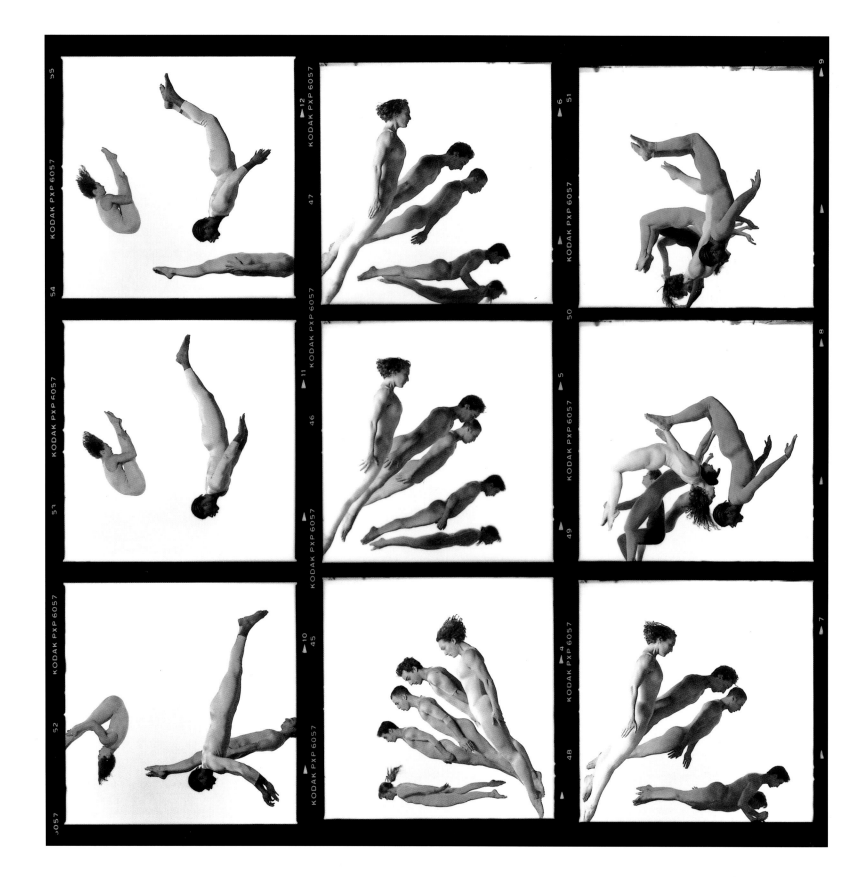

exercising total aesthetic control. Hoyningen-Huene, for example, evoked classical Greek dance by having his dancers lie on the floor with the camera overhead, the better to arrange the folds of the dresses precisely as in classical Greek sculpture; had the dancers actually been in motion, the fluid veils and dresses would never have conformed precisely to his stylized design. George Platt Lynes, justly celebrated for his magnificent photographs of Balanchine's ballets, also chose to work in the static manner, painstakingly posing and lighting the dancers to compose exquisite tableaux of perfect dance moments.

But a few photographers continued in the Arnold Genthe, or 'real time', tradition. The well-known graphic designer Alexey Brodovitch made a virtue of technical limitations, employing slow and contrasty film to photograph the dancers of the Ballets Russes de Montecarlo as blurred and shadowy ciphers. At the other end of the spectrum, the photojournalist Gjon Mili used the strobe, newly invented by Harold Edgerton, to freeze with spectacular clarity an exuberant instant in the Lindy Hop, and to analyse, in Marey-like style, a complete *pas de bourrée* as danced by Nora Kaye. And Barbara Morgan, who entered into a fruitful creative partnership with Martha Graham, settled upon a spontaneous, almost 'reportage' approach to photographing the dancer which was brilliantly suited to Graham's expressive emotional style. The collaborative *War Theme* (1941) was a milestone in dance photography because the piece had been conceived not for the stage, but for the camera, thus putting the two art forms on a truly equal footing for the first time.

Admittedly, this all seems rather long ago; sadly, few are the high points of dance photography since 1950. Possibly this explains the originality of Greenfield's vision: she felt free to propose a whole new approach to the genre, or at least to take as her starting point that brief, collaborative spark represented by *War Theme*. Since 1980, no single photographer can rival Greenfield's achievement.

It was at Brandeis University in Massachusetts that Lois Greenfield launched her career as a photojournalist, working for Boston's countercultural newspapers and covering, as she puts it, 'a quintessentially early seventies circus of rock stars, demonstrations and riots'. In 1973, three years after graduating, she moved back to New York City, where she married and established herself as a reportage photographer specializing in the dynamic cultural sphere. An assignment for the *Village Voice* to photograph a Nureyev/Paul Taylor collaboration whetted her appetite for the dance. Further work followed for the *Village Voice, Dance Magazine, Time, Newsweek* and *Rolling Stone*. Meanwhile, Robert Wilson's *The Life and Times of Joseph Stalin* opened her eyes to the potential of avant-garde theatre. Greenfield's interests meshed well with the prevailing spirit in contemporary dance, which identified with experimental tendencies in

Opposite
Contact sheet. Hope Clark,
Albert Elmore Jr. and Matthew
Stromberg, STREB/RINGSIDE, 1996.
See plate 74.

painting, sculpture, conceptual art, film and theatre rather than with the ballet. The notion of space itself was questioned across the spectrum of the arts: artists rejected the principle of a single, fixed point of view for any artwork, and choreographers questioned 'the stage' as the sole rightful performance site. Working with Paul Taylor, Laura Dean and Twyla Tharp, among others, Greenfield realized that a whole new vocabulary and grammar of dance was evolving, and that New York City was at the very centre of this experiment. Soon she had convinced her editors at the *Village Voice* to run her pictures alongside their regular dance reviews. It would prove a long-lasting alliance.

But it was not long before Greenfield tired of reportage dance photography, meaning the kinds of pictures taken during actual performances or at rehearsals. She realized that such photographs could at best be only pale documents of onstage reality. Furthermore, too many constraints limited the photographer in such situations: lighting effects were designed for the stage rather than with the needs of the photographer in mind; it was impossible to ask that a particularly photogenic moment be repeated until the photographer was sure she had it on film; the angle of view and the distance from the action on stage were prescribed; and, lastly, sets and decor which worked well on stage could be extremely distracting when they appeared fragmented in the backgrounds of photographs.

Greenfield's solution was to acquire her own studio, where she could exercise sufficient, if not absolute, control over these considerations. Here she could focus all her energies on a certain dancer or group, while they could in turn concentrate on what was demanded of them by the photographer. It was her *métier* to produce dramatic and original imagery for myriad dance companies, choreographers and performers who were part of the New York City dance world or merely passing through. Week after week, for more than twenty years, dancers and choreographers of every stripe have stopped by her Lower Manhattan studio to leave a permanent visual record of their otherwise ephemeral art.

This record consists of several different kinds of image. In addition to the 'journeyman' genres (that is, those images meant to serve for publicity and promotional purposes, as well as historical records), Greenfield developed others. In sum, there are six distinct genres, and it is important to distinguish between them.

First, there are photographs in which Greenfield attempts to capture *the essence or spirit of a particular dance* rather than depict a specific movement or gesture visible in the stage performance. Example: plate 20.

Second, there are efforts to seize *a literal choreographic moment* from a specific dance – that is, something very similar to what would actually be seen in the theatre. Example: plates 5 and 6.

Then there are photographs in which Greenfield attempts to capture the *essence of a choreographer's style* rather than represent a specific dance. Example: plate 13.

Opposite
Contact sheet. Arthur Aviles, 1993.
See plate 48.

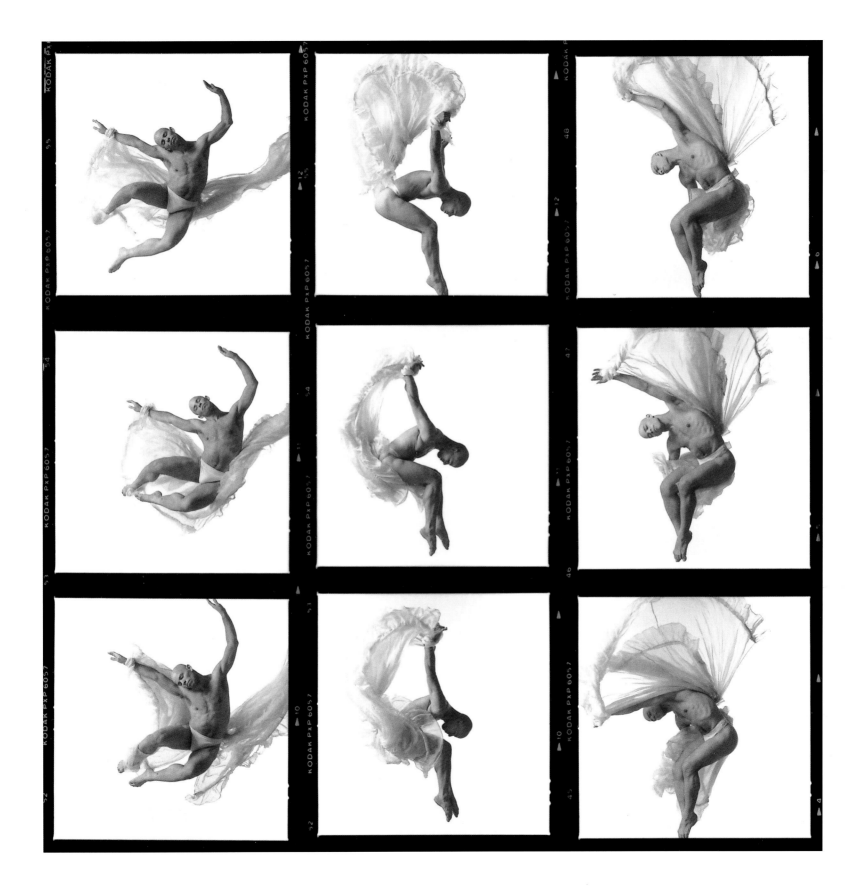

Fourth, there are photographs in which Greenfield tries to portray *the unique attributes, or style, of a particular dancer.* Example: plate 44.

Fifth, there are situations in which Greenfield herself *starts out with a preconceived idea in her mind.* Example: plate 9.

Finally, there are experimental sessions in which *both Greenfield and her dancers improvise, allowing their imaginations completely free rein.* With some of these sessions lasting as long as eight hours, there is enough time for both parties fully to investigate the potential of new movements, gestures or group dynamics. Example: plate 78.

Fundamental to each of these approaches is the use of the square format, in which the image is bounded on its four sides by the black borders which represent the camera frame. Unlike the theatre stage, where the horizontal (that is, gravitational) element dominates, and the vertical dimension represents only momentary escape, the square frame equates the horizontal and vertical vectors: freed of gravity, so to speak, the dancers float, fly and hover. (This is, of course, by no means the only distinguishing mark of a Greenfield image. For a fuller analysis, see *Breaking Bounds: The Dance Photography of Lois Greenfield*, William A. Ewing, 1992.)

Considered in its entirety, this vast archive of modern and postmodern dance imagery would alone have earned its creator a special place in the history of dance photography. What makes her contribution all the more interesting, and important, however, is Greenfield's refusal ever to be satisfied with those *métier* aspects of her work. As her vision matured, she came to see the dance rather as a landscape – that is, though it was undoubtedly beautiful and varied in itself, it was, from another point of view, merely raw material. Thus, she would ask her dancers to 'leave their choreography at the door', so that she and they could strive together for something original: a synthesis of dance and photography which put the two arts on an equal footing. It is within this ambitious enterprise that the photographer has obtained her greatest pleasure and her finest results.

ACKNOWLEDGMENTS

Many colleagues and friends have provided help and inspiration for my second book of dance photographs. Firstly, of course, I must thank the immensely talented dancers and choreographers with whom I have had the privilege of working: their enthusiasm and creativity have been the catalyst for my own creative process.

I am also, once again, deeply indebted to Bill Ewing for his discerning selection of my images and for the imaginative structure he devised in which to present them.

In my studio, Jack Deaso has been my creative partner since 1983 and has brought his talent, generosity and humor to all our photo sessions. I have been very lucky to have had such an encouraging and loyal friend. Thanks, Jack.

No photographer can ever have had a better team. Ellen Crane and Douglas Dugan have contributed in countless ways to the success of so many projects, both in the office and on the set. Jaime Perlmuth has made the most beautiful prints of my work, including all the prints in this book. Marsha Pinkstaff always offers me constructive criticism. Even the newest members of our studio family, David Loeb and Sean Gillis, have worked hard behind the scenes, doing whatever needed to be done.

Pierre, Claude and Jacques Bron of Bron Electronik have helped me to solve the important technical problems that arise from photographing dancers moving at high speeds. Without the short flash duration of their strobe units, I would be unable to capture as sharply the moments I search for. The personal attention they give me has been much appreciated. Thanks are also due to Mark Rezzonico of their New York office.

I have worked with Hasselblad cameras since 1982 and their effect on my photographic vision has been dramatic. Their fine instruments provide the resolution and sharpness I think essential to my work. Skip Cohen, Tony Corbell and Ernst Wildi of Hasselblad, New York, have been great troubleshooters.

Finally, I want to thank my husband Stuart Liebman and my sons Alex and Jesse for the pride they take and the love they give.

INDEX